CUBA

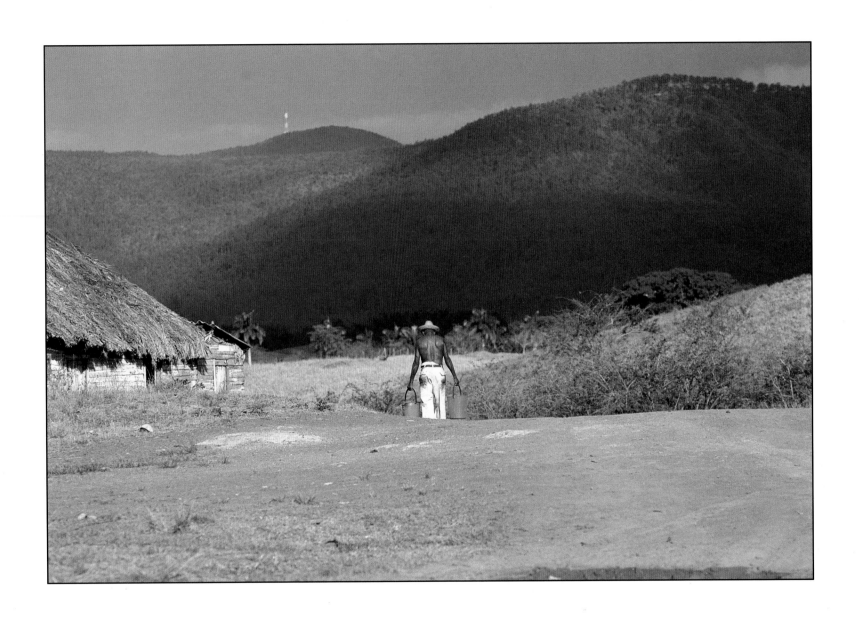

CUBA

ADAM KUFELD

INTRODUCTION BY

TOM MILLER

W • W • NORTON & COMPANY • NEW YORK • LONDON

Also by Adam Kufeld
El Salvador

Also by Tom Miller
Trading with the Enemy
The Panama Hat Trail
On the Border

Frontispiece: Farmer. Pinar del Río.

Printed in Hong Kong

This book is composed in New Aster
with the display set in Balloon Bold.
Composition by Trufont Typographers, Inc.
Manufacturing by Four Colour Imports, Ltd.
Book design by Candace Maté.

First Edition

ISBN 0-393-03509-3
ISBN 0-393-31023-X (pbk)

W. W. Norton & Company, Inc., 500 Fifth Avenue, New York, N.Y. 10110
W. W. Norton & Company, Ltd., 10 Coptic Street, London WC1A 1PU

1 2 3 4 5 6 7 8 9 0

CONTENTS

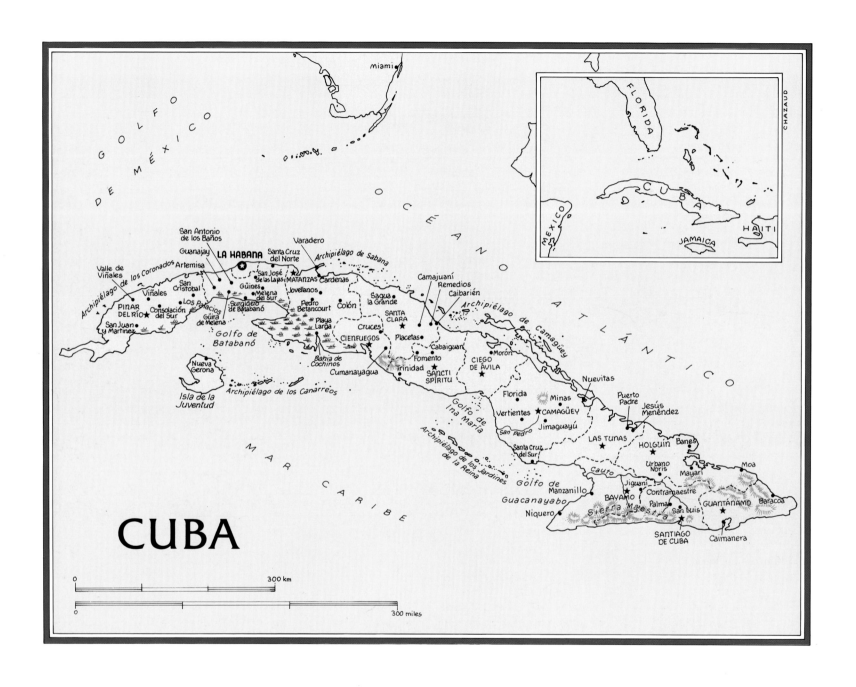

CUBA

Miami

GOLFO DE MÉXICO

OCÉANO ATLÁNTICO

Archipiélago de los Coronados

Valle de Viñales

San Antonio de los Baños
Guanajay
LA HABANA
Santa Cruz del Norte
Varadero
Archipiélago de Sabana

Artemisa
San Cristóbal
Viñales
Güines
San José de los Lajas
MATANZAS
Cárdenas
Camajuaní
Remedios

Consolación del Sur
LOS PALACIOS
Melena del Sur
Jovellanos
Sagua la Grande
Caibarién

Archipiélago de los Coronados
PINAR DEL RÍO
Güira de Melena
Surgidero de Batabanó
Pedro Betancourt
Colón
SANTA CLARA
Archipiélago de Camagüey

San Juan y Martínez
Golfo de Batabanó
Playa Larga
Cruces
CIENFUEGOS
Placetas
Cabaiguán

Nueva Gerona
Bahía de Cochinos
Fomento
Morón

Isla de la Juventud
Archipiélago de los Canarreos
Cumanayagua
Trinidad
SANCTI SPÍRITU
CIEGO DE ÁVILA
Nuevitas

Florida
Minas
Puerto Padre
Jesús Menéndez

Golfo de Ina María
Vertientes
CAMAGÜEY
LAS TUNAS
HOLGUÍN
Banes

San Pedro
Jimaguayú
Urbano Noris
Mayarí
Moa

Archipiélago de los Jardines de la Reina
Santa Cruz del Sur
Cauto
Jiguaní
Contramaestre

MAR CARIBE
Golfo de Manzanillo
BAYAMO
Palma
San Luis
GUANTÁNAMO
Baracoa

Guacanayabo
Niquero
Sierra Maestra
SANTIAGO DE CUBA
Caimanera

0 300 km

0 300 miles

FLORIDA

MÉXICO

CUBA

JAMAICA

HAITI

CHAZAUD

INTRODUCTION

BY TOM MILLER

Cuba lies precariously between nostalgia and calamity, trying hard to encourage the former and harder still to stave off the latter.

Nostalgia takes many forms, depending on who's reminiscing, and when. Cubans, in the post-Soviet era, long for the far higher standard of living in the recent past. Foreigners remember lively prerevolutionary Cuban vacations full of delightful sin. Cane cutters look back to the seasons of high sugar production. In the early twentieth century, American expansionists looked with favor on the U.S. role in 1898, first helping Cuba beat Spain, then helping itself to Cuba.

If nostalgia sentimentalizes history, then certainly photography heightens nostalgia. Cuba was among the first Latin American nations to develop photography. Adam Kufeld stands among the best of the most recent wave of photographers to roam the island capturing the people of this achingly beautiful land in perilous transition. His pictures follow a tradition dating back to the first daguerreotypes, which arrived in Havana in 1840. A couple of months later Cuba's first photo studios opened, inaugurating a history that has intertwined with the country's political turmoil. Slave rebellions had already begun, and incipient abolitionist and independence movements against impervious Spanish rule had erupted by this time.

Charles DeForest Fredricks was both an entrepreneur and a photographer. From his studio in New York, Fredricks set out in the mid-nineteenth century to establish branches throughout Latin America, including one in Cuba. A rare cache of photographs taken in the 1850s by Fredricks's Havana crew shows family scenes, weddings, sugar plantations, and formal portraits. "Photographs, Cuban publicists understood, could be used to counter negative stereotypes," writes Robert Levine in a book about Fredricks's work. Fredricks's pictures are formal and stilted, but they do allow a glimpse of society. The sign above El Telégrafo Gran Hotel, for example, reads larger in English than Spanish, suggesting a preference for foreign guests. Nineteenth-century photographers were not social critics, notes Levine, they were hired shutters. "No one paid photographers to shoot poverty."

As Cuba staggered through short-lived rebellions and unsuccessful wars of independence, those who could afford cameras took to this wondrous new toy. By 1886, when slavery in Cuba was finally abolished, Havana's amateur photography club boasted one thousand members. Cuban exile poet-philosopher José Martí, who had moved to New York a few years earlier, worked tirelessly promoting the cause of his homeland's independence. Portrait photography was common in New York by

this time, and dozens of pictures show Martí during his fifteen-year residency in the States. In almost all he wears a somber look, never hinting at the pleasure in his poetry or his vision of Cuba's future.

Spain continued to exercise control over Cuba, allowing occasional pockets of social and economic autonomy. None of this quelled the growing independence movement, and in 1892 Martí formed the Cuban Revolutionary Party, calling for armed struggle to achieve complete separation from the motherland. From Tampa, New York, and elsewhere he rallied support; his *compañeros* inside Cuba coordinated their efforts with his. The final prolonged chapter in the war for independence began in earnest in early 1895. The gaunt Martí returned to Cuba undercover, still wearing his trademark black frock coat and tie. He was killed in his first battle. The moment is preserved in sculpture at the Avenue of the Americas entrance to Central Park in New York, where Martí's body twists in agony as a bullet strikes him astride his startled horse.

Cuba was gaining in the countryside and Spain held on to the cities. In early 1896 Spain sent Valeriano Weyler to command its 200,000 troops. The ruthless general soon began a rural pacification program in which *campesinos* were either killed outright or taken from their land and herded into horrific concentration camps called protectorates. Among the insurgents in the field was the occasional amateur photographer, and pictures of Weyler's brutality made their way into the international press. For the first time photography in Cuba was used for political ends.

War photos showed up with increasing frequency in U.S. newspapers. Barefoot insurgents, independence fighters in dirty white clothes and cane cutter hats, and Spanish regulars in formation—the cumulative image drew North American readers inside a war in a way they had never before experienced. When the battleship USS *Maine* mysteriously exploded in Havana harbor—it had been sent to protect U.S. interests— the American public eagerly supported both sides of the jingoistic war between the Hearst and the Pulitzer newspapers. The Hearst *New York Journal* coined the phrase "Remember the *Maine*, to hell with Spain," and offered a $50,000 reward for turning in the guilty party. For its part, the Pulitzer New York *World* sent deep-sea divers to the scene. Circulation of both papers soared.

Cuba beat Spain, with help from the United States, but Spain turned the island over to the U.S. military, not to Cuban civilians. As one 1899 book put it, after the Battle of Santiago "the Spanish flag which had floated over the old city for nearly four centuries was furled forever, and the Stars and Stripes were triumphantly raised." Superpowers negotiated the conditions of Cuba's very life, and not for the last time, either.

Cuba was among America's first major acquisitions since two-thirds of Mexico fifty years earlier, and the public was fascinated with its nearby exotic possession. Promoters brought out color brochures of Cuban landscapes to entice visitors. The U.S. military occupation formally began in 1899, and Cuba ended the century as it had each of the previous four—under foreign rule.

Nothing determined Cuba's direction more in the following decades than the Platt Amendment, legislation written by the U.S. Congress to become part of Cuba's new constitution. The document required Cuba to accept U.S. military intervention in its internal affairs; it restricted the way Cuba spent its money at home and abroad; and, finally, it obligated Cuba to lease land for a U.S. Navy base. In the face of mass protests throughout the island, U.S. Secretary of War Elihu Root huffed indignantly that Cuba's attitude showed "ingratitude and lack of appreciation." In 1901, Cuba's constituent convention reluctantly copied the U.S. mandate word for word into the new constitution. Two years later the U.S. Navy began construction of a base at Guantánamo Bay; the lease agreement authorized U.S. use virtually in perpetuity.

By 1902 Cuba claimed seventy photo studios, almost half of them in the provinces. To boost interest in mass market photography, Eastman Kodak and other foreign companies offered workshops in film processing and awarded $4,000 gold in a photo contest. Coverage of Cuban affairs in the U.S. press subsided, but pictures came back with itinerant photographers who traveled to the island hoping to find customers there and good images to sell back home. None, apparently, ventured as widely as Minnesotan Sumner Matteson who, in 1904, spent four months traveling from Baracoa in the far northeast to Pinar del Río in the west. Eschewing sensationalism for serenity, Matteson photographed sponge fishermen, cane cutters, and pineapple packers at work, and city-dwellers and sharecropper families in repose. Palm groves and thatched huts on land contrasted with banana steamers, pole boats, and

yachts on coastal waters. The modest patio of a Havana home showed the era's architecture: grillwork and shutters over the windows, and arches over the doorways. Matteson was obviously taken with *campesinos*; one photograph of a smiling black youth in the countryside he captioned, "The Cuban Darkey Seems the Most Contented of Mortals."

Tomás Estrada Palma, who assumed office as Cuba's first president in 1902, was reelected in 1905 in a vote contested by the Liberal Party. Since the birth of the Cuban republic three years earlier, thirteen-thousand land speculators and investors had come from the States to buy an estimated 60 percent of Cuba's countryside. U.S. companies swallowed up the sugar, mining, tobacco, railroad, and utility industries. Banking was left to Spaniards, who emigrated in record numbers. The opening years of the Cuban republic was a time of grand opportunity for everyone except Cubans.

When an August 1906 uprising in Pinar del Río spread across the island, President Estrada asked for U.S. help to quash it. Secretary of War William Howard Taft arrived and Estrada soon resigned. Taft called in the marines, who began a twenty-eight-month occupation of the young country. Taft became governor of the provisional government, then turned Cuba's reins over to another Theodore Roosevelt appointee. The U.S. allowed Cuba another stab at elections in 1908, this one won by the Liberal Party candidate. The new president's most enduring contribution to Cuban culture was the reinstatement of the notoriously corrupt national lottery, which had been briefly suspended during U.S. occupation. In 1912, an armed uprising by an outlawed Afro-Cuban party protesting conditions for blacks met a firm military response not only from Cuban soldiers, but also from U.S. gunboats rushed to Havana harbor and marines setting out from Guantánamo. The rebellion's leaders were captured and executed.

Cuba's next president, a Conservative, established a pattern that many of his successors adopted: he rooted out the corruption of his predecessor, only to forge new frauds of his own. When the Liberal Party rose up in 1917 claiming the Conservative reelection that year a sham, the United States again sent the marines, many of whom stayed until 1922. Other people came from the United States with a different motive: Cuba was becoming a convenient and hospitable playground during Prohibition.

A politician from the Liberal Party succeeded the Conservative as president, and Enoch Crowder—Cuba's U.S. baby-sitter, appointed by Woodrow Wilson—steered the country's efforts toward political reform and economic policies benefiting North American investors. The next president, a wealthy industrialist and a veteran Liberal politician, rode into office on a wave of widespread reformist sentiment. His name was Gerardo Machado y Morales.

President Machado did well by acting on campaign promises for highways, schools, health care, and construction. Cuba felt the debilitating force of the Great Depression at the end of his first four years. The country's one-crop economy suffered mightily when world sugar prices tumbled, but the president's drastic cuts in production brought even more misery—first to cane cutters, then to the country at large. As Cuba looked forward to another presidential race, Machado announced that because of the demands of governing, the next term would last six years and he himself would fill it.

Profits, wages, and employment collapsed. Jobs and salaries that hadn't disappeared were drastically diminished. Political opposition grew, and the Cuban Communist Party flexed its muscle with organized labor. Hunger marches, strikes, and anti-government demonstrations became common. Tourists continued to visit Havana, the well-off staying at the newly constructed art-deco Hotel Nacional above the Malecón.

Langston Hughes, with a growing reputation for his poetry about black North America, stayed at a small rooming house when he visited from a Harlem winter in early 1930. "It seems years since I've felt such warmth or seen such a sky," the twenty-seven-year-old wrote back to the States on arrival. His trip, ostensiby to find a composer with Afro-Cuban rhythms for his folk opera, quickly turned into a nonstop literary celebration. Some of his poems had already been translated into Spanish, and he was wined and dined by the black and mulatto literary elite, flattered by society, and hailed by the press. With Nicolás Guillén he talked about their poetry, its tempo and its negritude. He saw one of the side effects of a racist society—a strong black and mulatto culture had grown by itself with its own joys and gentry, its own social clubs and fine restaurants, and its own literature. With the national situation wor-

sening daily, it was still possible to slip in and out of Cuba and absorb its best.

He left just in time. Government repression, lurking but not yet in full view, surfaced to violently quell a nationwide anti-Machado strike, and the situation deteriorated to mayhem. Ruthless repression, rebellion, reprisals, retaliation, and revolution all violently swept away whatever semblance of order Cuba could claim. Random bombings and mass jailings were common. Hand-tinted postcards from that era show cheerful city strollers buying goods from smiling curbside merchants.

Against this backdrop of chaos in Havana's streets Carleton Beals, a crusading journalist familiar with Latin American politics, visited the island in the fall of 1932. "Beneath the tropical opulence of Cuba, hidden in the tangled jungle of her present cruel political tyranny," he wrote, "are the fangs of bitter discontent. Cuba, unless a remedy is soon found, will be reaped to the holocaust of civil war." Beals blamed Machado, but he also faulted an American policy toward Cuba that "has helped drive her to despair and ruin."

Beals detailed the situation in *The Crime of Cuba*, and his publisher, desiring photographs to complement the text, asked Walker Evans to spend a couple of weeks in Cuba with his two cameras. Evans, still a few years away from *Let Us Now Praise Famous Men*, took some four-hundred black-and-white photographs, thirty-one of which were printed in the back of Beals's book. He captured the formality of military ceremony, the homeless sleeping on park benches, and common citizens blanketed by the odor of a decaying regime. He went inside courtyards and along back streets. His portraits of Havana's washer-women, newsboys, and dock workers showed clarity and dignity. His photos from nearby villages revealed the simplicity and pride of rural life. With his money running out, and evidently bearing a letter of introduction, Walker Evans called upon Ernest Hemingway and spent a third week in Cuba at the famous author's expense. His images reveal the habitual activities of daily life that continue under brutal dictatorships, even those perilously close to their demise. "It was a perplexing job," he wrote Beals upon his return, "so many different courses to follow. I wonder if the illustrations will seem Cuba to you, as you know it."

Cuba was at war, slaughtering itself on a battleground with little direction, no front, and an indeterminate outcome. "Outwardly Havana was a tomb," Beals wrote, "in reality it was a boiling cauldron." Diplomat Sumner Welles, sent to Cuba by newly inaugurated President Franklin D. Roosevelt, began mediation between most factions in early July. Havana radio incorrectly announced that Machado had resigned and thousands of people ran into the streets shouting, "Long live free Cuba!" Machado's forces mowed them down, killing twenty. Walker Evans wrote Carleton Beals: "The old butcher seems firmly in, still, for some time to come."

The old butcher had to contend with a general strike, shutting down industry, transportation, and schools throughout the country. One by one Machado's supporters abandoned him and signed on to the Welles blueprint, and when the army did likewise, Machado fled the country. Welles chose Carlos Manuel de Céspedes as Cuba's provisional president.

After one month, students and army officers, including thirty-two-year-old Sergeant Fulgencio Batista, overthrew de Céspedes in favor of a junta, whose hand-picked president, Ramón Grau San Martín, so annoyed the U.S. State Department by unilaterally revoking the Platt Amendment that it refused to recognize him. Grau's reformist tenure, with its slogan "Cuba for Cubans," lasted a bit more than four months. It ended with the recently promoted Colonel Batista, now chief of the army, ousting him in favor of two presidents over the next three days. Finally Batista picked a president with U.S. approval, and kept him in office almost two years. A succession of puppets followed, and the two countries agreed to nullify all the provisions of the Platt Amendment except the one allowing the U.S. Navy to live at Guantánamo Bay. On the photographic front, Rafael Pegudo staged an exhibit of nudes at Havana's Club Fotográfico, but the gallery's director, described as "a very straight Spaniard," closed it to the public. Many of the models were famous prostitutes of the day. Pegudo later brought out a book, *The Photographic Nude*.

Having been pilloried and sabotaged by foreign governments and exploited and corrupted by their own, Cubans arrived at a relative calm in 1940 with a new constitution that included enlightened attitudes on elections, public welfare, workers rights, and civil liberties. Fulgencio

Batista, by then a general, put his marionettes away and ran for the presidency himself. Cuban voters, attracted to his progressive platform, gave him a four-year term.

Thomas Merton was delighted with his discoveries as he drifted through Cuba that same year. "Boy, what a place," the future monk said of Havana after watching a flamenco stage show. A father and daughter greeted his bus in a small pueblo with florid songs, composed on the spot, about each passenger. Camagüey was "a swell town," he wrote, "full of cowboys on small horses." Merton sought out priests wherever he went, impressed by their worldliness. He gave an impromptu talk on metaphysics at the central square in Matanzas. A letter home lamented Cuba's prevailing sentiment about blacks: "They won't let them hold big dances in the public squares of small towns."

Batista stepped aside from presidential politics at the end of his term to let his prime minister lose to Grau, who in turn lost in 1948 to his own minister of labor. That was the last time Cubans went to the ballot box to chose among candidates for president. Placing third was Eduardo Chibás, a firebrand whose subsequent weekly anti-government radio broadcasts put him in the public spotlight. The funeral following his dramatic on-the-air suicide in 1951 brought together a broad spectrum of Cubans fed up with gross corruption and domestic gangsterism that had polluted public office. It was covered by Constantino Arias, a photographer who documented slum dwellers in their *solares* and the elite in their lairs.

In 1952 Fulgencio Batista again became a presidential candidate. But with three months left in the campaign, he and the military upstaged the process with a bloodless predawn coup d'état. The new dictator dissolved the congress and canceled the upcoming elections. Harry Truman recognized the infant regime right away. Among the congressional candidates suddenly with no seat to run for was a clean-shaven law school graduate, twenty-five-year-old Fidel Castro.

All talk, no action—for more than sixteen months that was the response among the disparate and dispirited anti-Batista forces. Then, during the 1953 carnival season, a sizable and heretofore unknown band made a brazen frontal attack on Batista's army barracks in Santiago. They were immediately overpowered: Batista's army captured, carved up, then killed more than seventy attackers, and tortured some of the rest. When they let the press in, a photograph of a battered but not yet dead attacker told the world of the ordeal. Later, the government captured a handful that briefly escaped to the hills, then tried and convicted them. Among this last bunch was the leader of the poorly planned attack, frustrated congressional candidate Fidel Castro.

Despite the fact that everything went wrong, news of the assault startled and energized more passive anti-Batista Cubans. In his presentencing speech Castro analyzed the country's history and outlined his group's philosophy. "Condemn me," he concluded, "it does not matter. History will absolve me!" Eighteen months later Castro and other imprisoned survivors, released early by Batista, went to Mexico to strategize the next phase of their revolution. The July 26 Movement (M-26), named for the date of the disastrous Moncada attack, was born.

No one dared run against Fulgencio Batista in the promised 1954 elections, and from the outside there appeared no reason to change leaders. Foreigners came by plane and cruise ships for a few days of pricey hedonism and went home happy. Others came to check their considerable manufacturing, mineral, or agricultural subsidiaries. The Du Pont estate was so enormous it had its own private customs officer. Constantino Arias continued his photography of Havana, from seedy nightclubs and self-important dignitaries to anti-Batista demonstrations and the city's underclass. In a photo-essay, Ernesto Fernández showed that fully 90 percent of Havana's lighted storefronts had signs in English. He called his exhibit "La Habana en inglés."

Batista refused to promise free elections, and students demonstrated against him. Many in Cuba's officer corps conspired unsuccessfully to retake the country from Batista. Guerrillas independent of M-26 struck at outposts and symbols in the countryside and the cities. White-collar groups in Havana called for reform. Prostitutes at Guantánamo demanded that sailors pay for their services in weapons, then turned the arms over to revolutionaries.

In exile, Fidel Castro, like José Martí seventy-five years earlier, raised money, secured arms, and coordinated overseas support. He followed Martí's path through New York and Florida, where he palled around with the Cuban community; his exhortations that they support M-26

from abroad were well-received. Back in Mexico City he met an asthmatic Argentine doctor who had been making his living as a roving photographer. His name was Ernesto "Che" Guevara, and he joined up with Fidel and Fidel's younger brother Raúl, and about eighty others for a wind-tossed week-long voyage to Cuba aboard a second-hand yacht called *Granma*.

Everything that could go wrong did. An insurrection in Santiago planned to coincide with the *Granma* landing was early and crushed, the yacht was late and lost, and no one came to greet the hapless M-26 crew when they drifted into swampland in the Gulf of Guacanayabo—except tipped-off Batista forces, who quickly killed more than three-quarters of the seasick expeditionaries. Fewer than twenty survivors set out through the Sierra Maestra to topple a dictatorship based on the other end of the island. The government said that Castro himself was among those dead.

Photographer Alberto Díaz Gutiérrez, better known as Korda, set up shop in 1956 near the Hotel Capri in the midst of the low-life high-rollers who helped give Havana its international reputation for debauchery. Korda's cheesecake photos in the weekly *Carteles* magazine reinforced the capital's sin-city image. His work became so well-established that it motivated other photographers to adopt his name—there were "Viejo Korda" and "Genevieve Korda," among others. Korda also inspired Códac, the photographer in Guillermo Cabrera Infante's *Three Trapped Tigers*.

Meanwhile, back in the Sierra, the M-26ers picked up support from peasants who had little to lose. One month after their landing, the ragged guerrilla army, somewhat expanded, overwhelmed a Rural Guard station. They managed to contact urban counterparts and coordinate a supply channel into the mountains. Herbert Matthews, a correspondent for the *New York Times*, was spirited into M-26's base camp for a clandestine interview. After the first of Matthews's three-part series came out, Batista officials claimed it a fake, that a reporter could not have slipped into and out of the Sierra undetected, and besides, Castro was dead. The next day the *Times* published a photograph of the reporter and his subject together at the guerrilla hideout.

The rebels set up their own covert radio station, Radio Rebelde, and newspaper, *Revolución*. Castro made a public plea for his countrymen to join him for a democratic Cuba with free elections. Hemingway's *For Whom the Bell Tolls* suggested tactical ideas to him. M-26 forces derailed freight trains and seized goods from government warehouses to augment provisions smuggled into their expanding *territorio libre*, and they made alliances with like-minded saboteurs. The sheer audacity of a failed assault on the Presidental Palace by an urban cadre helped transform underground fervor to popular discontent. Rebel forces grew to an estimated fifty thousand strong. "The President's regime was creaking dangerously towards its end," wrote Graham Greene in *Our Man in Havana*. No known photographs exist of Batista's escape to the Dominican Republic after midnight New Year's Eve, 1959.

Fidel Castro took his time getting to Havana. During the first week of January he motored through small towns toward the capital; photographs show euphoric throngs swarming through the streets, frozen in joyful celebration. It was, wrote photojournalist Lee Lockwood, "one of those rare, magical moments of history when cynics are transformed into romantics and romantics into fanatics."

Castro set up shop in the top floors of the recently opened Havana Hilton; card sharks and croupiers continued to work the first floor. Photographer Korda soon went from the Hilton's lower levels to its uppermost reaches; Castro picked him as his personal photographer. When the Agrarian Reform Institute, charged with land redistribution, was initiated, veteran photographer Raúl Corral Varela, known as Corrales, was charged with documenting its progress and breakthroughs. This gave Corrales carte blanche in the field. "Cavalry," his photograph of a squad of revolutionary horsemen hoisting the Cuban flag as they enter a United Fruit Company sugar mill called Preston (since renamed Guatemala), symbolically reenacts a plantation takeover from the war against Spain before the turn of the century.

So much took place so fast in the opening years of the Castro era, and so much of it was highly visible, that anyone with a camera, film, and a trained eye could see the seismic shifts in progress. Housing, literacy, health care, sports, farming, defense, music, crop harvest, mass media, wages, dairy farming, nationalization, rent control, art, transportation, land ownership, education, food distribution—these and dozens of other daily influences went through fundamental change in the revolution's formative period. If Cuba has had the capacity to absorb worsen-

ing situations no matter what their severity, the corollary may also be true: that the country had the ability to adjust to new and untried ways. Certainly it appeared that way in those initial years. Yet even then, in retail shops signs cautioned, "The Customer Is Always Right Except When He Attacks the Revolution."

In March 1960, a French freighter full of Belgian armaments inexplicably blew up in Havana harbor, much as the *Maine* had sixty-two years earlier. The explosion killed one hundred people. The United States had asked Belgium to cancel the delivery which, along with its campaign to sabotage the sugar harvest, made it the prime suspect. The next afternoon Castro again took to the masses in a speech condemning the United States. As the platform was readied, Che Guevara, then president of the National Bank, made his way down the front row. "To the camera," Henry Cartier-Bresson has written, Che's "eyes glow; they coax, entice, and mesmerize." That's just what Korda must have thought as Guevara, wearing a windbreaker zippered to the neck and a beret dotted with the revolutionary star, suddenly came into his Leica's viewfinder. He saw Guevara's hard and determined visage, his head tilted slightly to the horizon, the wispy mustache, and his eyes burning just beyond the foreseeable future. *"Me asustó,"* Korda has since said. "I was shook, physically taken aback." Guevara appears in only two frames on the contact sheet; Korda cropped out a palm tree to one side and an anonymous fellow on the other, and came up with "The Heroic Guerrilla," among the most reproduced photographs ever taken. That day Castro introduced *¡Patria o Muerte!* into the national lexicon (Fatherland or Death), later revised to *¡Socialismo o Muerte!*

Castro gave a speech at the United Nations that same year in which he encouraged world disarmament and Chinese membership in the UN. The Cuban press entourage included *Revolución* editor Carlos Franqui, propagandist of the M-26 campaign. In a picture of the first meeting between Fidel Castro and Nikita Khrushchev, he stands anonymously next to the two, a little to the rear. Castro ended up lodging at New York's Hotel Theresa, where a wide range of visitors called on him, including Abdel Nasser, Jawaharlal Nehru, Malcolm X, Allen Ginsberg, Langston Hughes, and Henri Cartier-Bresson, who took pictures.

Trade was winding down with the United States—in 1958, fully 69 percent of Cuba's imports came from the United States—and the Soviet Union and its Eastern Bloc allies picked up the substantial slack. The country's equilibrium, thrown off course by its previous patrón, was being righted by its new boosters.

Campesinos benefited from the revolution in its first year. Initially landless farmers got individual plots under Agrarian Reform, a program later expanded and revised in favor of collectivized cultivation over personal ownership. Teachers and health workers anchored themselves in the *campo*, where neither before had devoted much time. The Cuban government was replacing United Fruit Company as the dominant force in the countryside.

On April 17, 1961, a force of about 1,400 Cuban exiles attempted to invade the island at the Bay of Pigs. The plan was to land at Playa Girón, secure some territory, and provoke enough nationwide chaos to foment a popular uprising against Castro leading to his death and the fall of his government. In the previous weeks a pattern of sabotage, from underground resistance within the country and planes arriving from foreign airstrips, had both frightened and mobilized Cuba. The invaders—trained, financed, and overseen by the Central Intelligence Agency—lost. A few were killed, some escaped, most were captured. Prime Minister Castro took credit for the triumph; President Kennedy accepted blame for the defeat. "Wasn't there anyone around to give you the lecture on Cuba?" Norman Mailer scolded the president afterward. "Don't you sense the enormity of your mistake—you invade a country without understanding its music."

Most of the coverage of the showdown, except inside Cuba, dwelt on the tactical errors and misplaced confidences of the invaders, and very little on the maneuvers and strategy of the defenders—in short, why the United States lost instead of how Cuba won. Usually victors write history; in this case they photographed it, too. (A picture book by Corrales, *Playa Girón*, holds up as the most revealing work on the conflict and its aftermath.) In the midst of the week's turmoil, Castro boasted, "we have made a revolution, a socialist revolution, right here under the very nose of the United States." It was the first time he had publicly acknowledged his revolution's orientation.

Victory at Playa Girón won Castro admirers throughout Latin America for beating back the bully and prompted a series of CIA attempts on

his life. At home it solidified his dominance. It also provoked irrational policies and odious repression. Orders came from the top for a one-time sweep of anyone perceived to be too independent of mainstream revolutionary support. Anyone in suddenly sealed-off bohemian sections of Havana and other cities who couldn't produce proper identification was arrested. Armed with lists, authorities sought out, according to Carlos Franqui, "homosexuals, vagrants, suspicious types, intellectuals, artists, Catholics, Protestants, practitioners of voodoo . . . prostitutes and pimps." The detainees had to wear uniforms branded with a large P on the back. That same year impoverished women and others in Cárdenas, the town that had had a concentration camp under Spanish rule, took to the streets demanding "freedom and food" and an "end to terrorism and persecution." The government responded not to the pleas but to the spectacle and sent in planes and tanks to quell the uprising. Unlike the terrors sixty-five years earlier, no photographs of this pacification effort made print to arouse indignation. Carlos Franqui began working on a photographic exhibition of the Cuban revolution, eventually escorting it through a half-dozen European and Asian countries. In Korea Kim Il Sung ordered the bikinis on mulatto *militianas* covered over.

The October Crisis of 1962 revealed the extremes to which the superpowers would clash in world-threatening one-upmanship. Nuclear missiles, rhetorical bluff, and diplomatic tiptoeing led to a conclusion acceptable to the United States and the Soviet Union; Cuba, again affronted by two superpowers determining its role, made lots of noise but gained little status.

The Kennedy-Johnson administration, its military invasion repulsed, initiated diplomatic efforts and sponsored sabotage to bring down Fidel Castro's government. Over the years it tried to isolate Cuba within the United Nations and the Organization of American States. Other countries, persuaded by behind-the-scenes diplomacy and threatened aid cut-off, distanced themselves from the island. Succeeding U.S. administrations did little to stop—and often encouraged—repeated hit-and-run attacks from air and sea by Cuban exiles. The most severe blow, however, was the Trading with the Enemy Act, which effectively curtailed personal and commercial contact between the two countries. (Just before invoking the act, however, President Kennedy, who smoked Cuban cigars, secured 1,200 Petit Uppmans.) Mexico stuck by Cuba throughout, remaining its most consistent Latin American friend from independence onward.

"Cubans of the militia," Henri Cartier-Bresson noted in mid-1963, "carry rifles the way a tourist carries a camera." The militia, a people's army called up during the victory at Playa Girón, had a strong presence throughout the country, but fewer and fewer tourists came, with or without cameras. The casinos and porn palaces had been shut down and the prostitutes sent to rehabilitative trade schools. The Havana Hilton became the Habana Libre. "It is as if the Amish had taken over Las Vegas," lamented Kenneth Tynan in *Holiday*. Cartier-Bresson called it "a pleasure island that has gone adrift," adding, "the people are easygoing and full of humor and kindness and grace, but . . . nobody will easily convert them into hard Communist zealots."

Cuba endorsed the Soviet invasion of Czechoslovakia with tortured logic: Castro called the action "drastic and painful," but "a bitter necessity." In the following years the nation flexed its military muscle first in Africa helping movements in their battles against colonial powers, then in Latin America against entrenched oligarchies. Cuba found itself on both sides of the Soviet invasion of Afghanistan in 1979. Afghanistan was a member of the movement of nonaligned nations, which Castro led, but Cuba felt compelled to back the Soviet Union, whose political support and financial assistance it had enjoyed for two decades. When the issue came to a vote at the United Nations, most of the nonaligned nations sided with Afghanistan. Cuba voted with Moscow, and its credibility among the nonaligned nations suffered severely.

By the late sixties Carlos Franqui, Fidel's *compañero* from the Sierra Maestra, had moved to Europe and denounced the regime he had served. Castro used photographic technology well: whenever that picture of Castro and Khrushchev at the United Nations has appeared in Cuba, Franqui has been air-brushed out, photographically disappeared. Húber Matos, another comrade from the early days imprisoned twenty years for questioning the Revolution's direction, was likewise air-brushed from history. He has been disappeared from photographs of triumphant guerrillas entering Havana in January 1959.

Cuba's trade missions overseas were bombed by revolutionary terrorists. In Washington, Congress reported numerous government-sanctioned attempts on Castro's life, with exiles participating. In 1977,

Washington and Havana traded low level diplomatic missions, the closest the countries had come to recognition in some fifteen years.

On April Fool's Day 1980, twelve Cubans crashed a minivan through the gates of the Peruvian Embassy in Havana, seeking asylum. Within days thousands of others joined them, and soon Cuba made a strategic decision: anyone who wanted to leave the country could. The rest of that spring and through the summer hundreds of boats of all sizes and powers arrived at the Port of Mariel west of Havana, where Cubans, unsure of their fate, crowded aboard for the ninety-mile ride to Key West, Florida. Families had to make immediate decisions that would affect them the rest of their lives. Some prepared to abandon their *patria* only to unpack at the last minute. Others were coerced to leave because they were prisoners, or considered counterrevolutionary. One divorced parent could prevent the other from departing if children were involved. "Did you hear? Pedro left, but Myrna and the kids stayed." *"Oye,* Carlos cried all night when Carlito announced he was going." The fiery subject burned through Cuba's consciousness during the sweltering summer of Mariel. Despite the scorn heaped on the émigrés in mass pro-government street demonstrations and by Cuban bureaucrats handling the departures, 125,000 Cubans chose to leave their own country before the program wound down five months later.

"You gave all of us who are alone in this country," Norman Mailer wrote Castro at the time of the revolution, "some sense that there were heroes left in the world." To some that image had been indelibly stained, yet Castro's Cuba, at the beginning of the 1980s, remained enormously popular throughout most of Latin America as the symbol of a developing smaller nation successfully standing up to an overdeveloped larger one. The qualities of the smaller one couldn't be turned into statistics— sunset along the Malecón and music coming from behind closed doors, colonial architecture in Habana Vieja and municipal bands in small-town plazas, and fine, dark sand on south coast beaches and tobacco leaves maturing under cheesecloth in the Viñales Valley. The international self-respect that Cuba had carefully nourished spilled over to its citizens with an intrinsic sense of dignity and egalitarianism far wider than in previous regimes.

Post-Mariel Cuba continued much as before. The country's commercial output increased slightly, but it was most proud of its sophisticated biotechnical industry coupled with advanced research in pharmaceuticals. Los Van Van, a big, brassy stage band with Afro-Cuban rhythms and sly street lyrics, grew in popularity with *habaneros* at local dance halls like the Tropical and in more formal settings for international gatherings. Pablo Milanés and Silvio Rodríguez developed international followings with their ballads of soft, personal optimism. The country's movie industry brought out films like *Memories of Underdevelopment* and *La Bella del Alhambre;* the reputation of its annual international film festival grew throughout the Americas. Although some of its more notable writers left the country, Cuba still maintained a productive literary output, its community of writers publishing what and where it could. Painters and other artists imaginatively stretched their limited resources to bring out widely interpretive modern and postmodern works.

In 1985, the American government began a station called Radio Martí, aimed exclusively at Cubans. Despite its distrustful nature, Radio Martí grew to become a principal in the propaganda war against Cuba. In 1989, on their own state media, Cubans became riveted to the sensational drug trial of ranking officials, best known among them the highly decorated and well-regarded General Arnaldo Ochoa. Although convicted of smuggling, the hasty execution of Ochoa alongside three others provoked widespread speculation about government motives and led many Cubans to question their own leadership.

Two months before Radio Martí began broadcasting, Mikhail Gorbachev assumed power in Moscow, and soon began assessing the Soviet Union's commitments.

In late 1988, when Gorbachev was the toast of the Western world, Castro said the Russian's reforms, if successful, "will be good for socialism and everyone else." If not, he predicted, "the consequences will be especially hard for us."

The repercussions were not long in coming. In the spring of 1989, 88 percent of Cuba's trade came from Warsaw Pact countries. Within a few years there were no Warsaw Pact nations to trade with. Cuba almost capsized. Its athletes were the only winners in those difficult years.

Cuba has managed to stay afloat while its former Eastern European

allies have sunk because, in part, Castro came to power as a popular leader, not a promoted apparatchik. His leadership, which many outside the country see as tenuous, from inside appears longlasting. The reservoir of loyalty and affection he has built up over the years has not drained below the danger mark. The Caribbean nation, long guilty of leaning on other countries for its support, began a long period of painful and strenuous readjustment. Cuba was finally, after some ninety years, independent.

<p style="text-align:center">* * *</p>

"I had cautioned myself against any undue romantic persuasion," wrote LeRoi Jones (later Amiri Baraka) when he visited Cuba in 1960. His was a well-advised warning, one that first-time travelers through the island should take to heart. It allows you to appreciate the country on its own terms and on no one else's. The 1990s have thus far been devastating for Cubans who have accustomed themselves to a higher standard of living. The country can buy almost nothing, including petroleum from overseas. Cuba has been forced to improvise spare parts for machinery. Anything that requires petroleum to operate—vehicles, elevators, power stations, farm and industrial machinery—has been reduced or eliminated. The sugar harvests, plagued by unseasonably awful weather and broken-down equipment, have yielded relatively small crops. Foreign tourism has become the most reliable hard currency source. The domestic economy has been mugged by the black market, where you can get anything you need—provisions, clothing, perfume, gasoline— at wildly fluctuating prices. A majority of Havana's work centers have stopped operating entirely. A television cooking show featured banana skin *picadillo* before a reduced broadcast schedule took it off the air after more than forty years. A new crop of Cubans has arisen along the Malecón, the underground economy's Wall street: *los bisneros*, those who do business. By this time the decades-old U.S. trade embargo had been toughened and expanded to pressure other countries' cooperation, making an unfortunate situation miserable.

"To return to capitalism would be a step backward in history," Castro warned his people in 1991. Two years later he took a couple of tentative steps in that direction. He decriminalized the possession of foreign currency in the hands of Cubans, an act that will help tremendously in the short run, but create social problems down the line. Small businesses, like repair or carpentry shops have been legalized, allowed to work independent of the state. The economy, near a standstill, began to creak and groan anew. "How is a Cuban like a seal?" a friend asked with a glint in his eye and a hand to his ears. "Because he's up to here underwater and he's still clapping."

If it is easy to enumerate Cuba's downward spiral, it is not impossible to find pockets of pleasure: baseball fanatics at the Esquina Caliente ("hot corner") in Santiago's Parque Martí gesticulating wildly over a game the previous night, neighborhood musicians and dancers sashaying down Havana's Prado boulevard in the city's annual anniversary party while thousands cheer from the sidewalks, and spontaneous participation in a community Santería celebration.

The success of the Revolution in 1959 and the convoluted history since is all the more remarkable because it is unprecedented. When Cuba falters, there is no role model from which to learn recovery; likewise, when Cubans benefit from their successes, that too is novel. Passions rise when people talk about Cuba because, among other reasons, it's such a lovely place, with a terrain to a large extent unspoiled and a population anxious to move on.

When Adam Kufeld first sent me his elegant photographs of Cuba, Walker Evans's words to Carleton Beals arrived with them: "I wonder if the illustrations will seem Cuba to you, as you know it." I had seen hundreds of pictures taken on the island in recent years, from Sabastião Salgado's brawny sugar mill workers to Paris *Vogue*'s pouty-lipped French model naked in a tobacco field. But unlike all the others, the photographs that follow seem Cuba to me as I know it. By coincidence, Adam Kufeld's time in Cuba overlapped with mine, and he followed a strikingly similar trail through the country: the Pinar del Río baseball team, the Border Patrol outside the Guantánamo Navy Base, music lessons, countryside high schools, the train to Matanzas, and Chanukah in Havana. We followed the same course at roughly the same time but curiously we never ran into each other. When I show these photographs to friends in Cuba they smile the highest of compliments: they recognize their country and themselves. Kufeld has achieved that rare perspective of looking at Cuba from the inside out, and in doing so, he has given us a gentle look at a hard place.

PHOTOGRAPHER'S NOTES

My path to Cuba has been circuitous, occasionally mystical, sometimes painful, and frequently beautiful beyond words. The journey began in 1964 in my high school auditorium. A fellow student was giving a slide show about Cuba—a place fixed in the American consciousness by the missile crisis, images of sugarcane, cigars, and the villainous dictator, Fidel Castro. In between her slides of hospitals, schools, and white sand beaches, there was one of her playing Ping-Pong with Fidel, himself—they were both laughing quite hard. I've always remembered those images, perhaps because I can't imagine any of my friends playing Ping-Pong (or anything else) with a president of the United States or perhaps because they could not have been more different from the images presented to us in our newspapers. It would be twelve years before I would see the bearded man and the mysterious neighboring island for myself.

In 1970, after working in my small basement photography studio and as an assistant to a fashion photographer in New York City, being swept up in the Civil Rights Movement, and protesting the Vietnam War, it was the time for personal growth and mind expansion. I headed off for five years of odd jobs and world travel.

The Amazon, the Galápagos Islands, the Andes, the Pampas: the beauty that I saw in these places astounded me. But traveling, I slowly became aware of the underbelly of the dream, the nightmare of poverty the likes of which I had never seen. In Ecuador I strolled blissfully through a colorful and, to my eyes, "exotic" Indian market in the Andes. I turned a corner to find a well-dressed Ecuadorean woman followed closely behind by her Indian porter. He carried her excess of goods on his back in a huge hemp bag held in place by a rough rope strap straining across his forehead. The porter's hat was a piece of beat-up felt which carried an embossed metal number—his number. He seemed more like a beast of burden than a human being.

Eating dinner by myself in Cali, Colombia, I heard small voices outside the window calling for "los huesos," which means "the bones." Four street kids (who I later learned were only four of several hundred thousand in Colombia) asked only that I leave them the bones from my chicken. I didn't understand—the land was as rich in natural resources as anywhere else in the world. There was oil, immense forests, and mountains rich with ore. The extremes of wealth and poverty hit me like a slap in the face. Contradictions like this abounded in Latin America, as they do in the rest of the world.

When leaving a town in Bolivia I came upon a shopkeeper who nervously pulled out an old magazine with Che Guevera's picture on the cover. I purchased it as a souvenir of my trip and carried it with me

through Argentina until I was ready to cross the border into Chile. I knew that Chileans would consider it subversive, so I decided to mail it to myself in the United States. At the tiny Argentinian post office on the border, an undercover cop demanded, "What is this?" I mumbled that I knew they didn't like this kind of thing in Chile. He informed me that they didn't like it in Argentina either. Ordering me to follow him, officials went through all of my belongings in a small dirty room before they let me go.

Back home it wasn't long before I found myself involved in politics. In 1976, I had my first opportunity to go to Cuba with the Venceramos Brigade, which since 1969 had been helping with the sugarcane harvest while learning about Cuban socialism. Once there, I was assigned the job of helping Cuban construction workers build a day care center. During the day we hammered and sweated; at night we talked politics; and on the weekend we toured the island. I was impressed—this was the first "Third World" country where I didn't see scores of children malnourished and without shoes. Children, I was told, were the only privileged class there.

In contrast to the Soviet Union and Bulgaria, where I had previously visited, people seemed happy in Cuba. The seventies had been a good period for the country—the economy was in relatively good shape; the Soviet Union was giving Cuba one million dollars a day; and they had trading partners throughout the socialist camp.

Color and music were everywhere. Art abounded. Every citizen was guaranteed a job, an education, and free health care. People put their energies into endeavors like creating a more collective society. I thought I had found paradise. After almost two months, I left Cuba with a belief that people were capable of more than simply struggling for the best job, the nicest house, the newest things. It was possible for people to work together for a common good. Was I a dreamer, a subversive, a fool? I started looking at other countries, other political systems and, ultimately, revolutions.

In 1985, after setting photography aside for almost fifteen years, I accompanied Gus Newport, then mayor of Berkeley, to El Salvador's war zones. I stayed to document the lives of the *campesinos'* struggle to end the cycle of poverty and violence in their country. As in Cuba, the humanism that I saw, even in the midst of war, reinforced my belief in

people. This led to seven more trips to El Salvador, and trips to Vietnam, Nicaragua, and the occupied territories of Israel. I wanted to see these places with my own eyes, rather than through mainstream American media.

Still searching for answers in a changing world, in 1991 I returned to Cuba to witness the effect of the demise of the Soviet Union and the socialist bloc. The country was not faring well. More and more goods were being rationed and new shortages were cropping up daily. Buses were breaking down and spare parts from the Eastern bloc were not arriving. Factories had to shut down. Because of the shortage of gas, thousands of bicycles replaced classic American cars and Soviet Ladas. Though the children still seemed well fed, it was becoming a concern. The thiry-year-plus U.S. blockade cut Cuba off from many of its nearest potential trading partners and made things more difficult for the average person. People were demoralized, but still spoke proudly of being independent and Cuban.

In an effort to raise capital, the government was encouraging tourism and joint hotel ventures with friendly nations: Spain, Mexico, and Canada. With tourism came contradictions and problems. Prostitution, virtually eliminated after the triumph of the revolution, was visible, even though it was often for a fancy dinner, a new dress, or new shoes, rather than for money directly. Incidents of theft, almost unknown before, became increasingly common. With American movies shown on television every Saturday night—and their endless images of fast cars, luxurious homes, and plenty of everything else—many young people born after the revolution began looking toward Miami as a way out of an increasingly austere Cuba.

While many grew disenchanted, others put their energy and creativity into solving Cuba's problems. They loved their country and didn't know what other options they had—many felt that "at least we're all in it together." To a great extent this is true. In Cuba, the highest paid worker can only earn about seven times the salary of the lowest paid worker. It is possible for a hard-working cane cutter to make as much as a doctor. Rationing goods further equalizes things. While there are shortages, the young and the elderly get priority regarding food and special dietary needs whenever possible. Unfortunately, some people still have access to goods that others do not, creating privileges for some and resentment

among others. In three trips over a two-year period, I saw things go from bad to worse. Many are frustrated with the authoritarianism and the intolerance of political dissent. Some quietly voice their desire that Fidel step down and let another person, maybe someone from the younger generation, take his place. Others still love Fidel and put all their hope and trust in him. And hardly anyone thinks capitalism is the answer.

Neighboring Haiti, Jamaica, the Dominican Republic, and Puerto Rico all provide sobering reality for Cuba on what a market economy has to offer a Third World nation. Hardly economic, political, or social role models. All one has to do is look at the rest of Latin America too see how bad things could really become.

I can't say where Cuba is headed, I know where it's been and I know what its priorities have been. While there have been contradictions and abuses of power, people and their needs have continually been the focus of Cuban society. There is an organic humanism that is rare in the United States. Cubans look out for others, whether the stranger is down the block or halfway around the world. Their ethos gives them a consciousness that makes them part of a human family.

Many questions remain unanswered. Not only about Cuba's future but about the future of socialism in general. Can societies that put collectivety and people first make it in this ferociously market-driven world? If not, what does the future of humanity hold? Other questions also need to be freely discussed. What happens when all basic needs are guaranteed by the state? When people don't have to worry about the quality of their work because almost no one gets fired? Or when state bureaucracies become so rigid that no one is willing to make decisions or take responsibility?

And what about the United States? Why do we blockade Cuba, yet grant favored-nation trading status with China? Every American president and Congress has tried to put an end to the Cuban experiment. It can't be in the name of democracy that we have tried to destroy Cuba. If that were so, we would have invaded Chile to save Chileans from Pinochet, but instead we helped put him in power. We would have aided Guatemalans who face genocide instead of supporting those committing the crimes. We would have opposed Marcos in the Philippines instead of counting him as one of our closest allies. I can only think that the United States has enforced the trade embargo for so long out of a fear that other countries might follow Cuba's attempt to be independent and keep their human and natural resources for their own use, rather than selling them to the highest bidder.

The Cuban people must be allowed to solve their own problems and to create the kind of society they need and want. That is any nation's right. Cubans have never tried to invade the United States or to impose their form of government on us. So why should we feel compelled to mold Cuba in our image? The United States should focus on solving its own many problems instead of attempting to force its model of government upon other nations.

With these photographs, I have attempted to show everyday life in Cuba. I have not focused on personalities or political leaders; that is another story altogether. The images here are meant to reinforce a belief that people are people, no matter where they live and no matter what type of social or political system they have chosen. They work hard, fall in love, root for a favorite baseball team, and rejoice and complain about life. Yet Cuba and the United States have been isolated from each other for over thirty years, our views obscured by propaganda and fear. In reality, I think, ignorance is our enemy, not the Cuban people. I hope this book and these photographs aid in better understanding a land and people too long mystified.

—A.K.

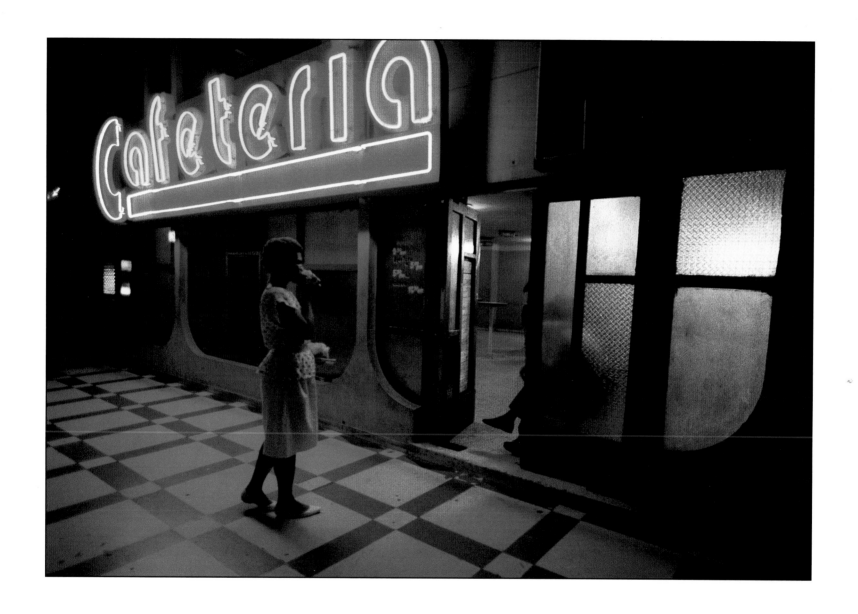

Cafetería Las Americas. Central Havana.

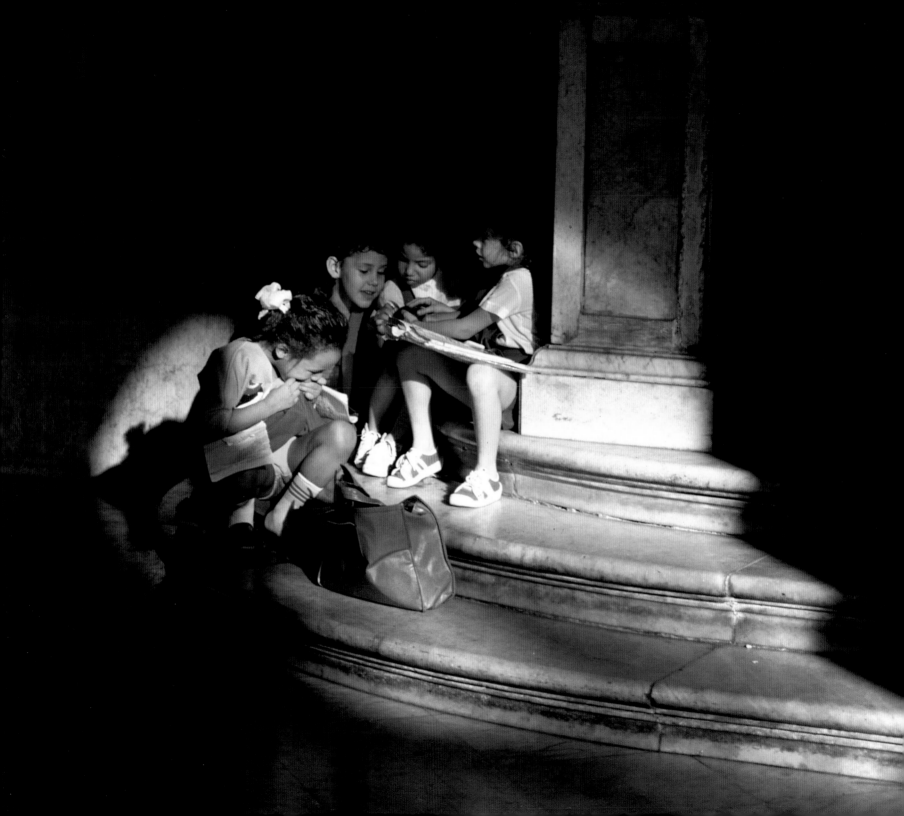

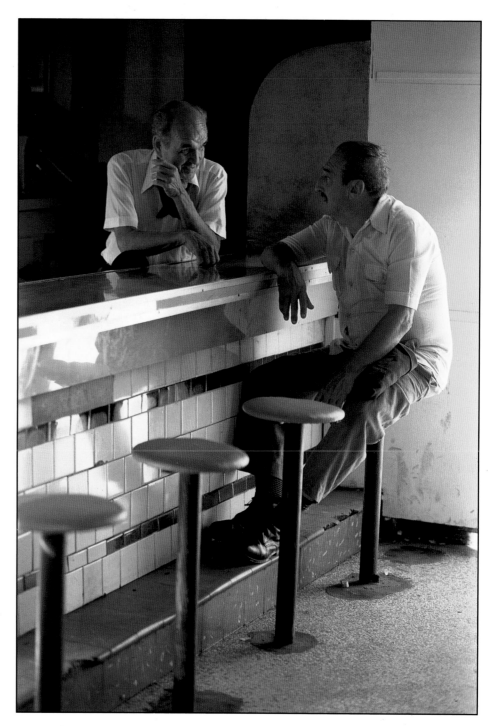

Opposite: Four of Cuba's over 850,000 elementary
school children doing their homework. Old Havana.

Near closing time in a café. Old Havana.

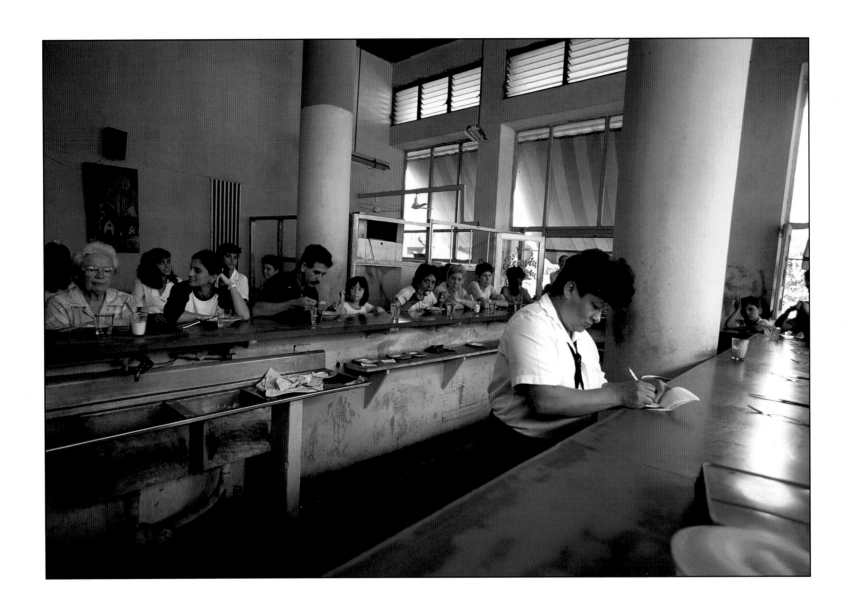

Lunch hour at the Milano pizzeria. Vedado, Havana.

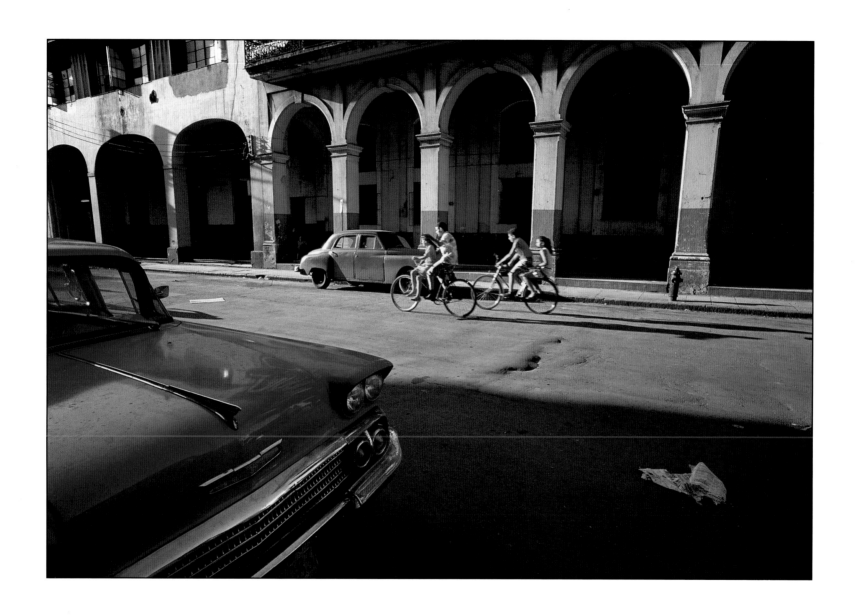

Old Havana.

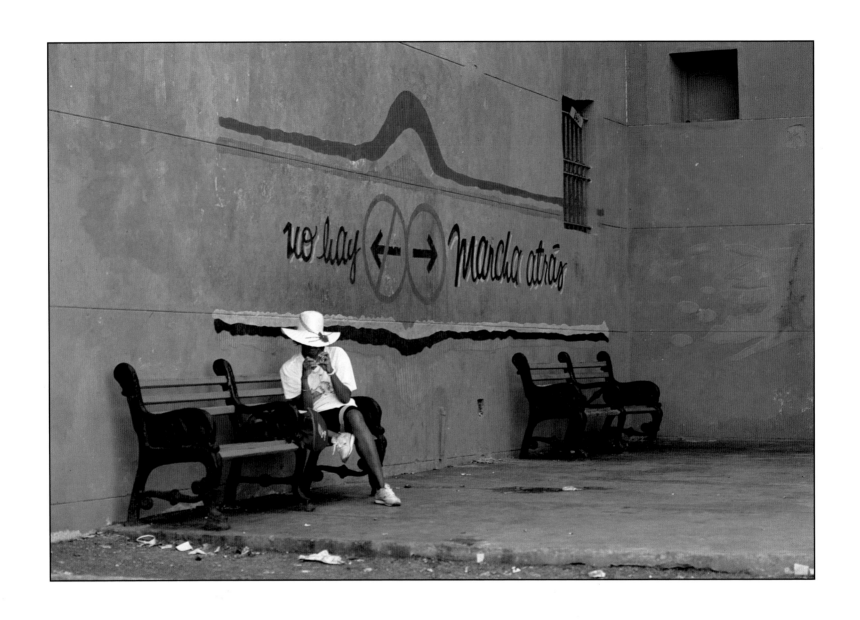

Political graffiti reads "There is no going back." Havana.

A once-Spanish mansion is now an apartment build-
ing. Old Havana.

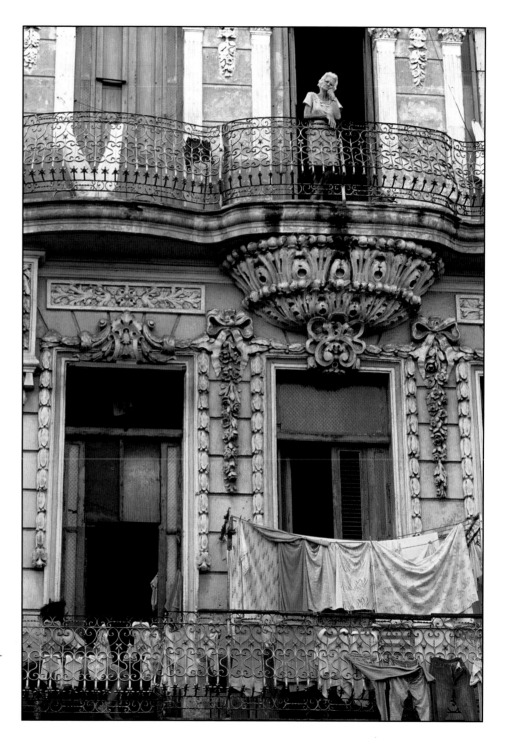

Nap time at an elementary school. Havana.

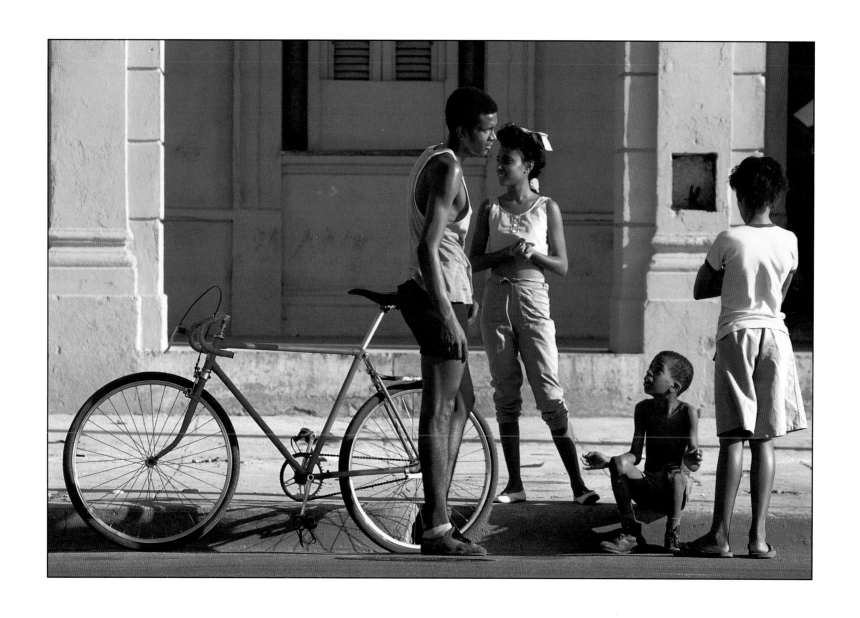

Sunday afternoon in Central Havana.

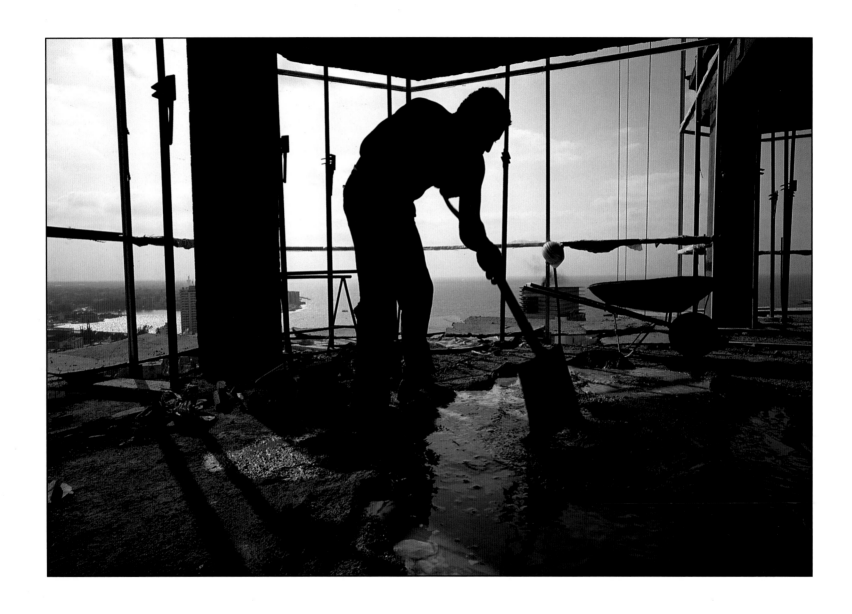

Cuban cement mixer working on the twenty-third floor of the Hotel Cohiba, a Cuban-Spanish joint business venture. Vedado, Havana.

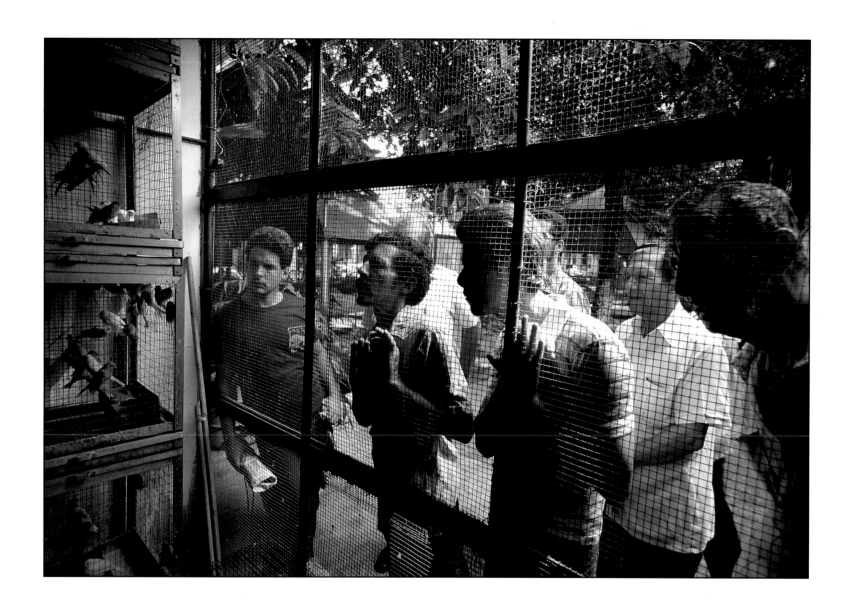

Visitors on the National Ornithology Association grounds, where they used to sell birds and seed to the public.
Vedado, Havana.

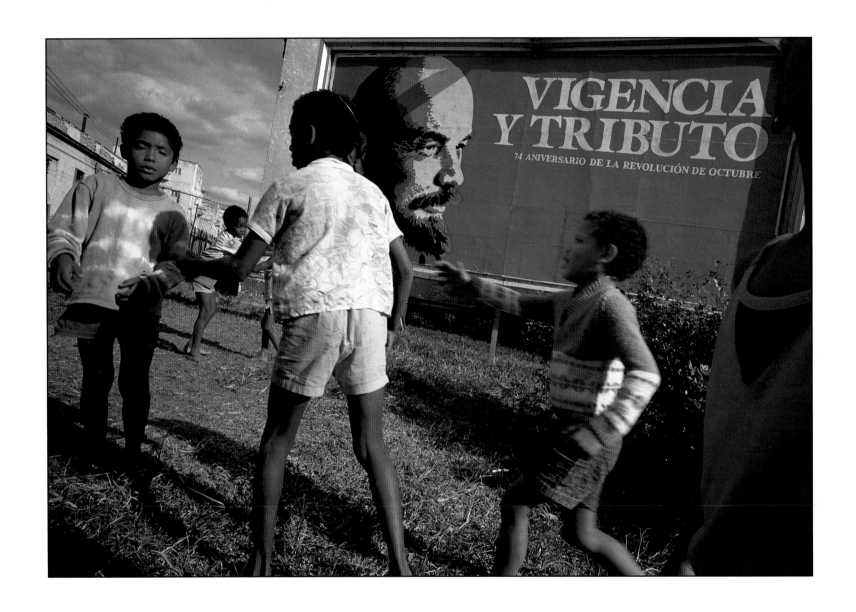

Children playing at the foot of a billboard that pays tribute to Lenin and the seventy-fourth anniversary of the October Revolution. Havana.

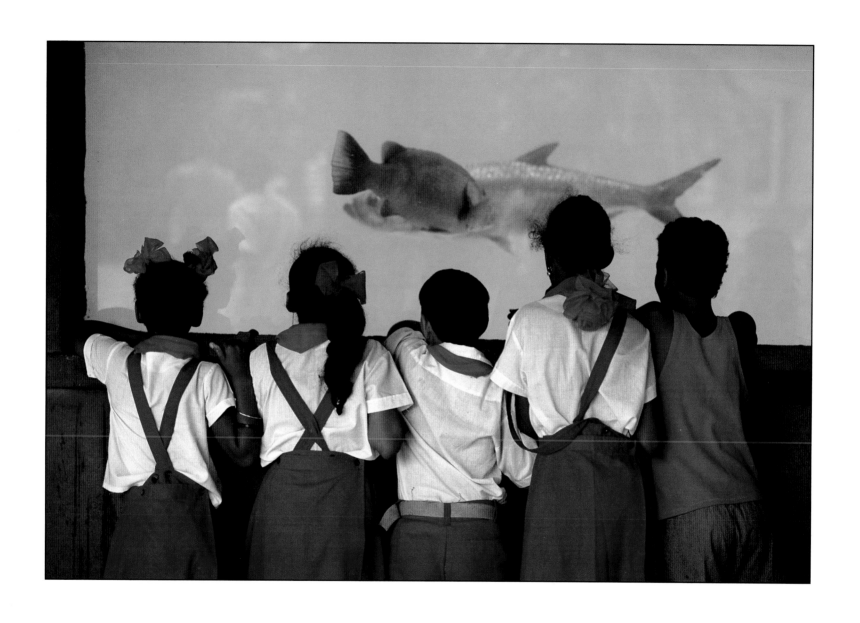

Schoolchildren at the National Aquarium. Havana.

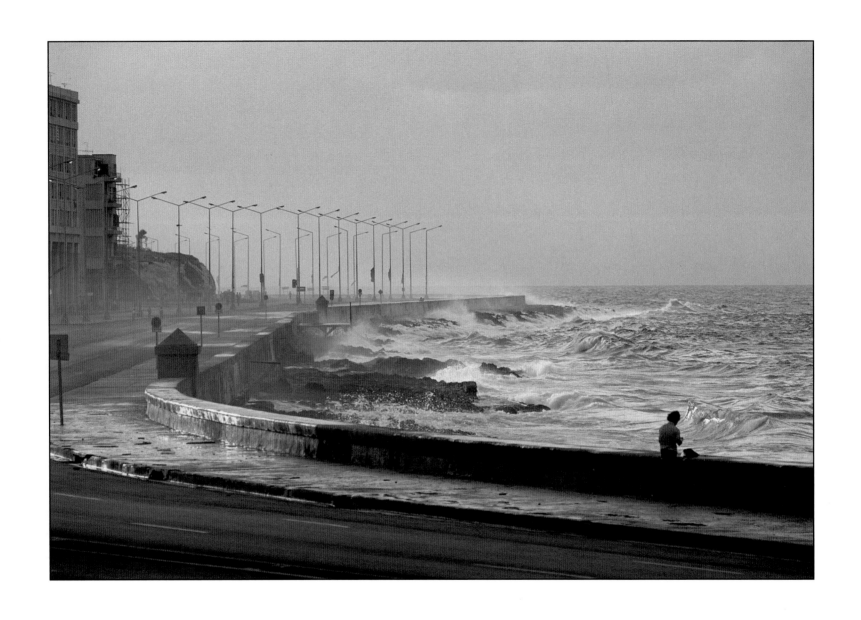

The Malecón. Havana.

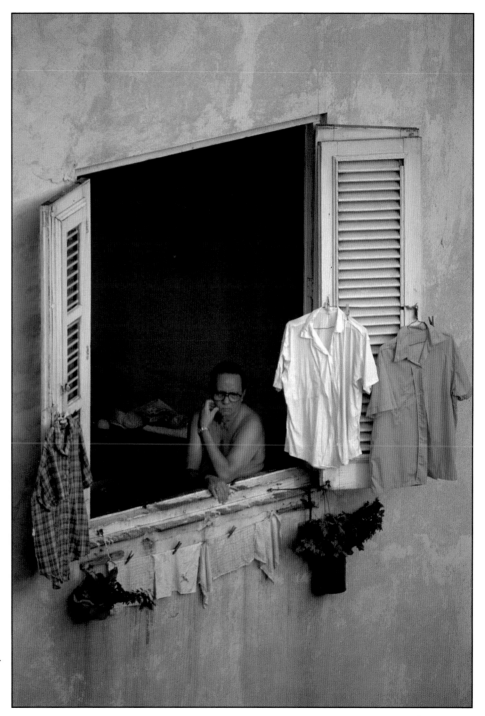

Gazing out a window. Havana.

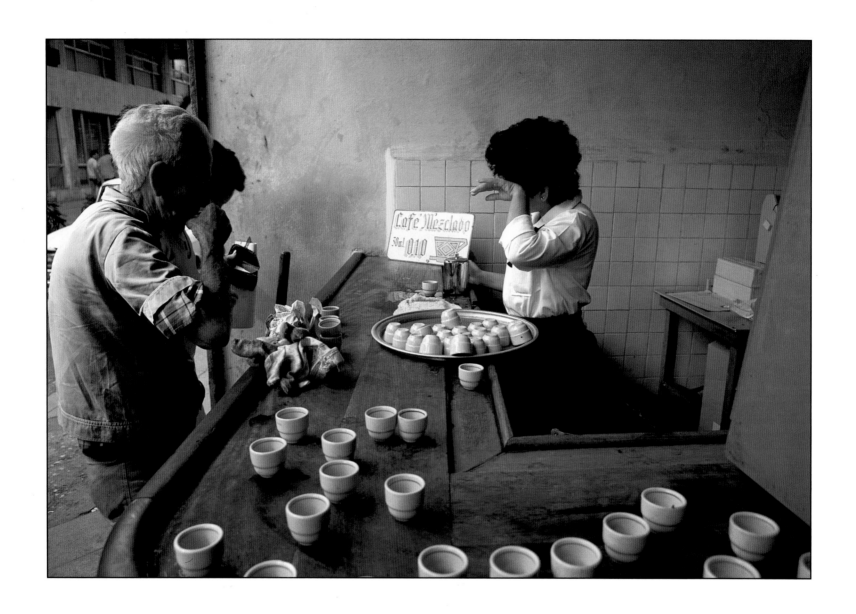

Ten *centavos* for a street-front cup of coffee. Old Havana.

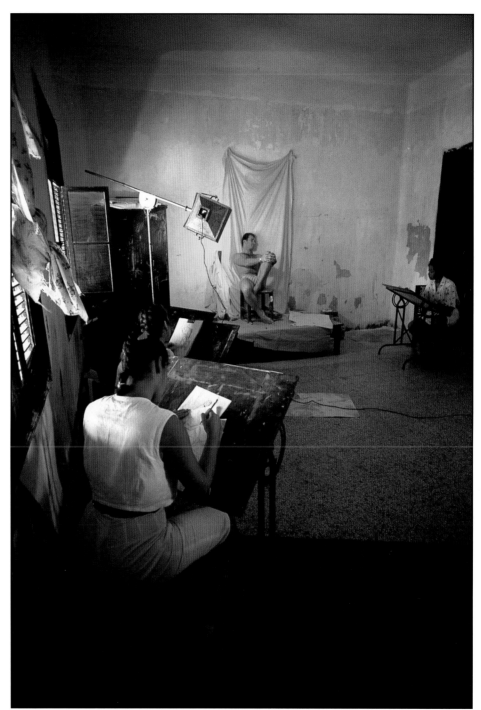

High school art class. Havana.

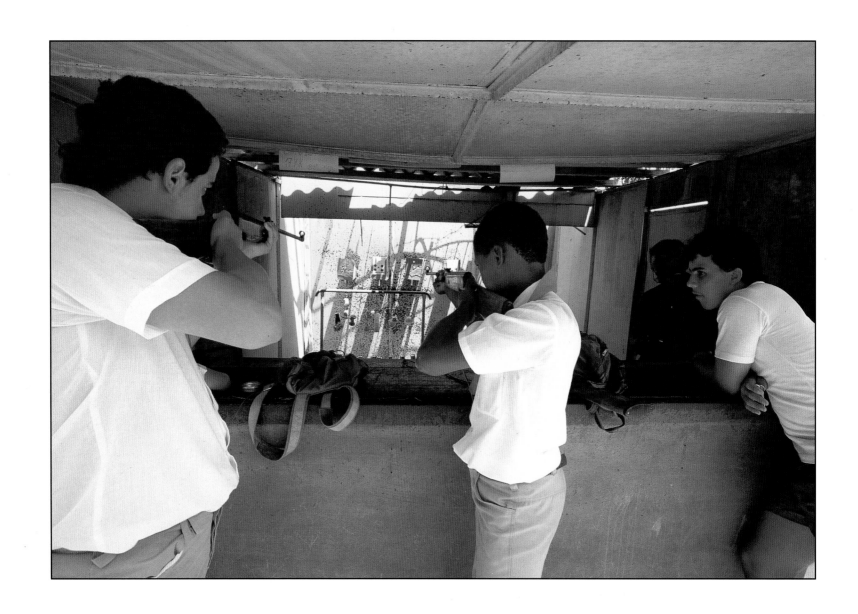

Junior high school students at a local shooting gallery. Vedado, Havana.

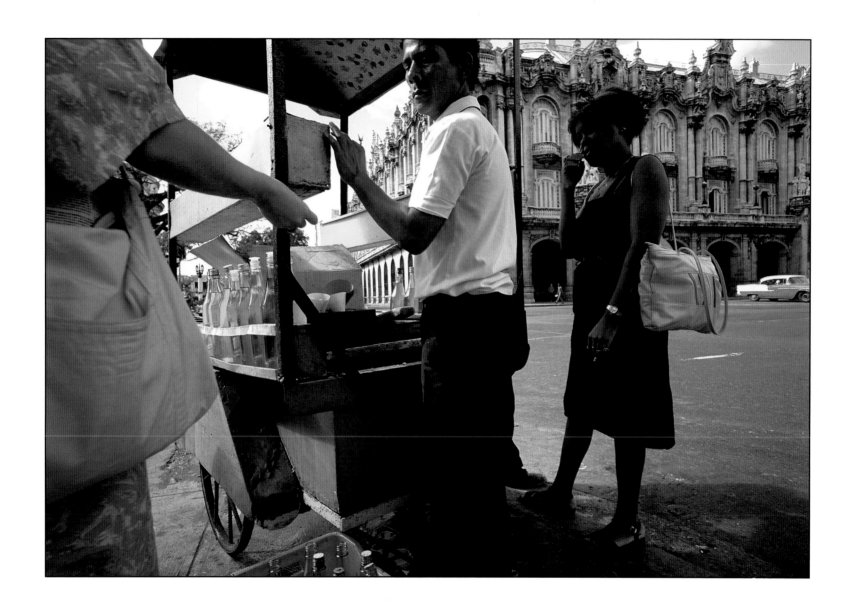

Old Havana.

José Martí Park, one of the capital's major sports complexes. Vedado, Havana.

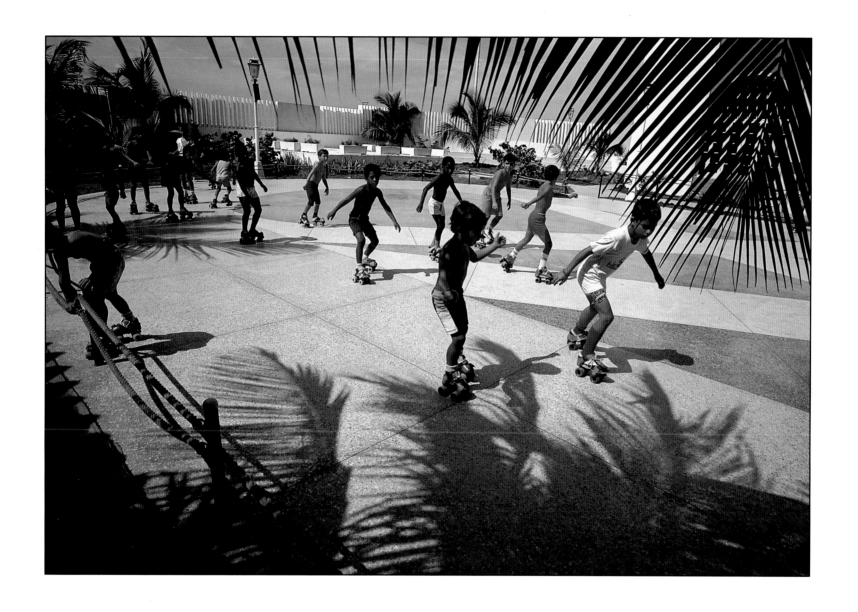

El Castillito, a recreational center with a discotheque, video arcade, snack bars, swimming pool, and nightly entertainment, run by the Young Communists League. Havana.

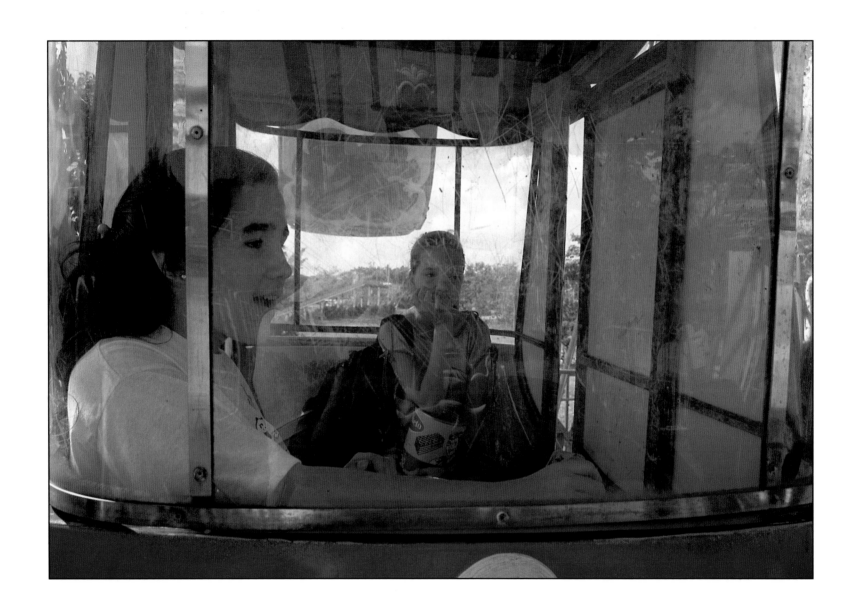

On the ferris wheel. Lenin Park. Outside Havana.

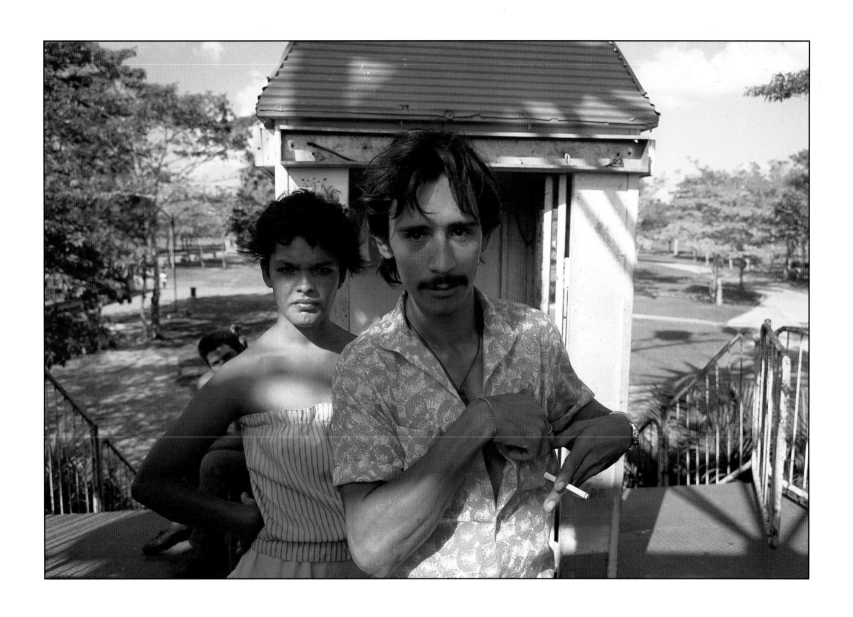

Waiting for the ferris wheel. Lenin Park.

"Cuban Cowgirls" prepare for their rodeo performance. Lenin Park.

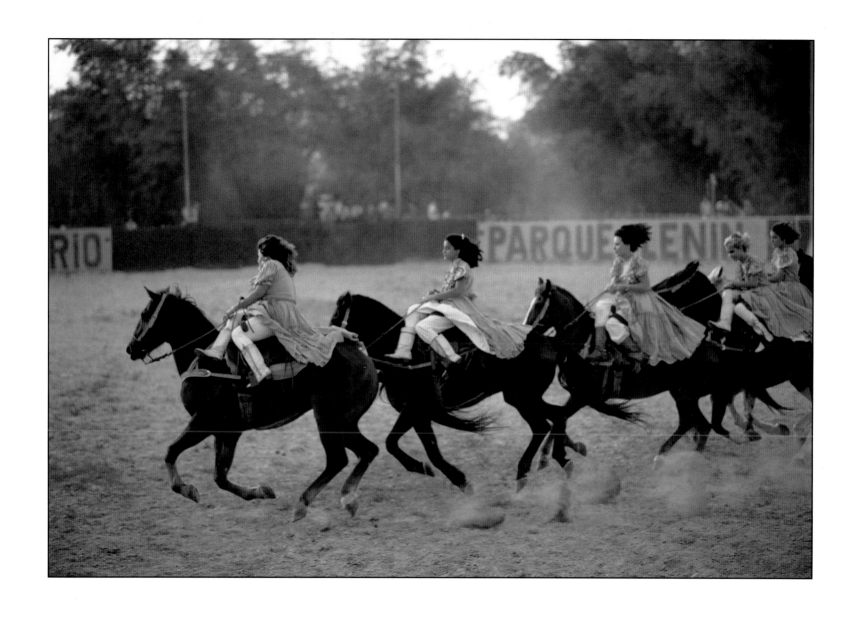

"Cowgirls" in the arena before the bull riders and ropers compete. Lenin Park.

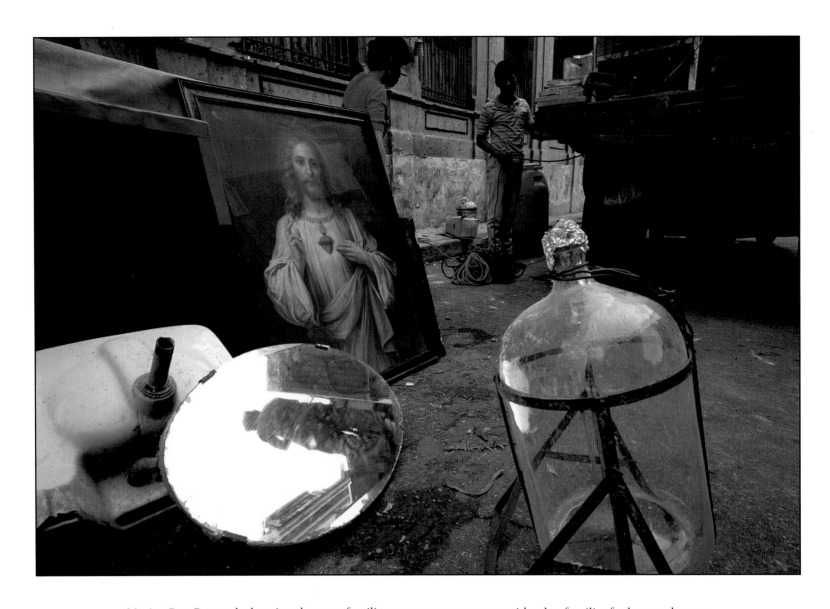

Moving Day. Due to the housing shortage, families may swap apartments with other families for homes closer to where they work, or for more room. Rent is never more than 10 percent of the head of household's salary. If they don't already own the home, rent is applied toward full ownership. Havana.

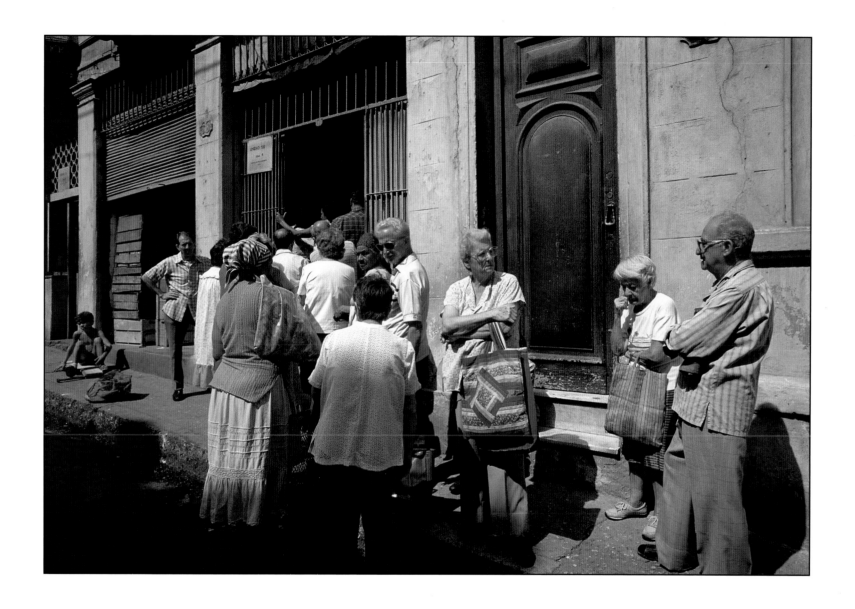

Waiting in line for eggs. Before the current economic crisis, eggs were available in unlimited quantities. Now, each family member is allocated a limited number of eggs per week at a greater cost. Vedado, Havana.

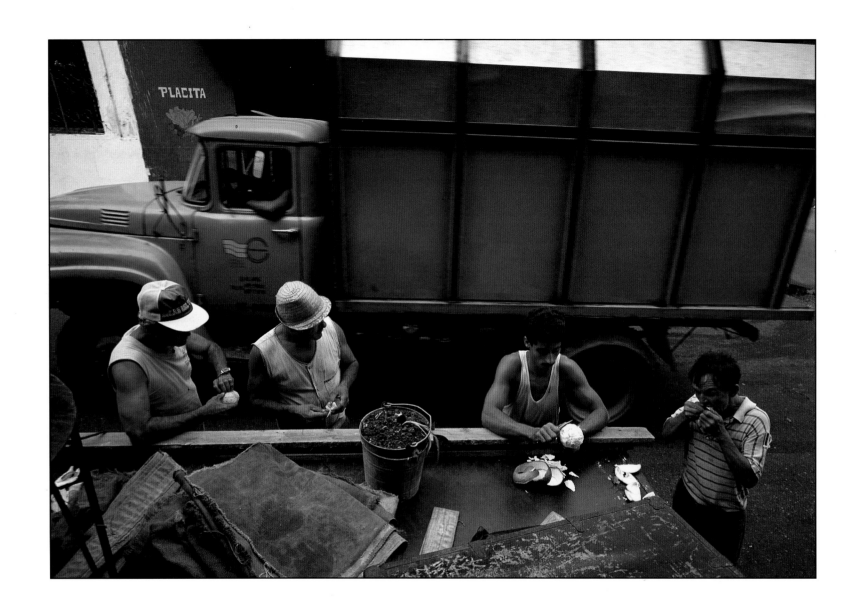

Moving men take a break. Vedado, Havana.

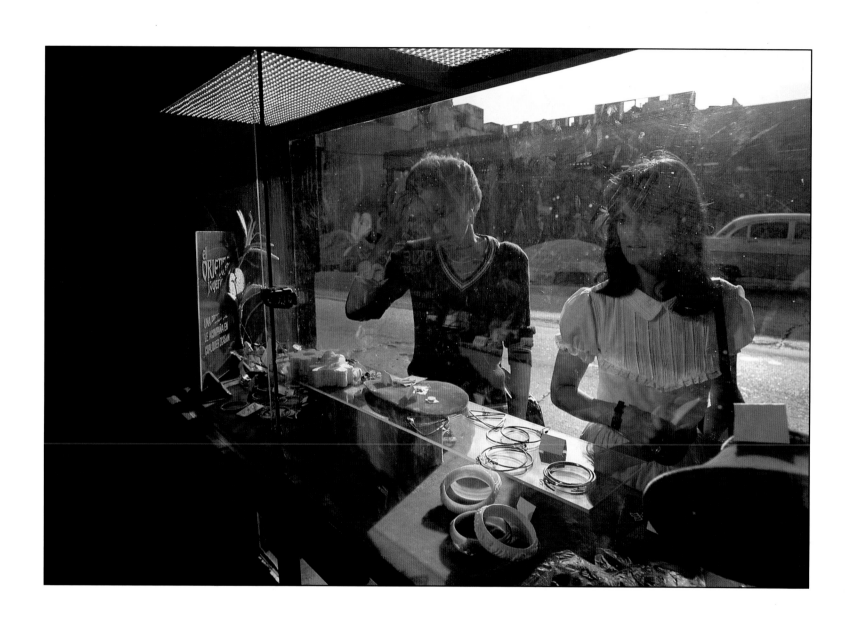

Window shopping in Old Havana.

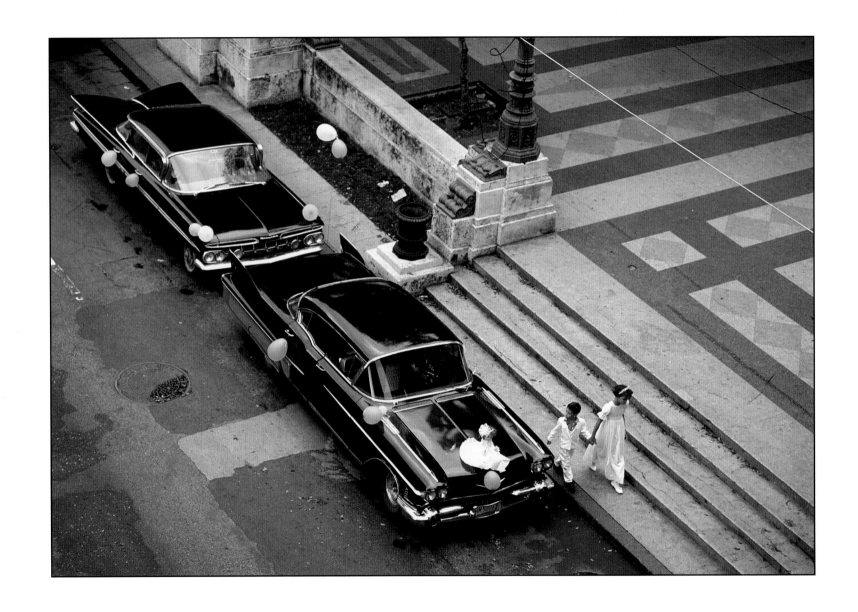

Waiting for newlyweds to emerge from the Palacio de Matrimonio. Havana.

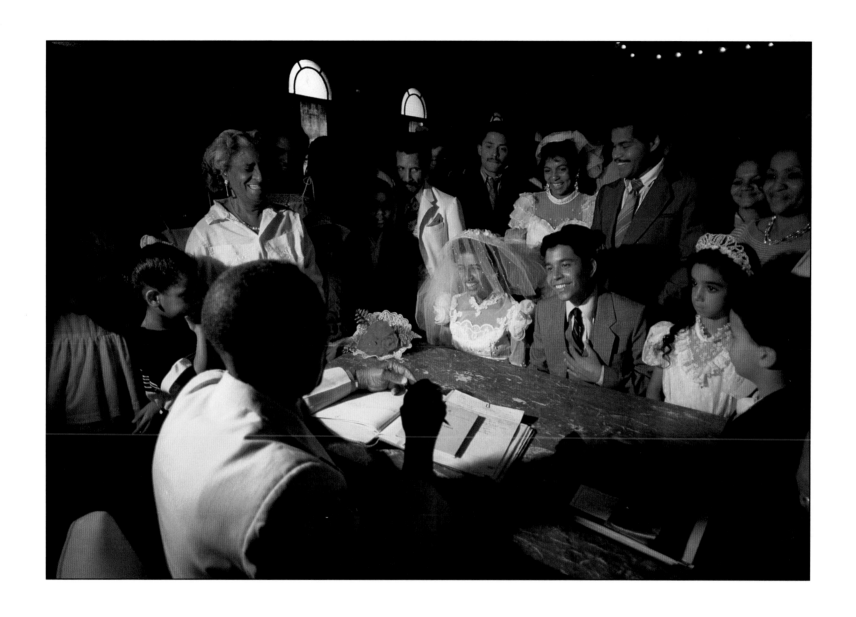

Inside the Palacio de Matrimonio where up to forty couples get married each Saturday. Havana.

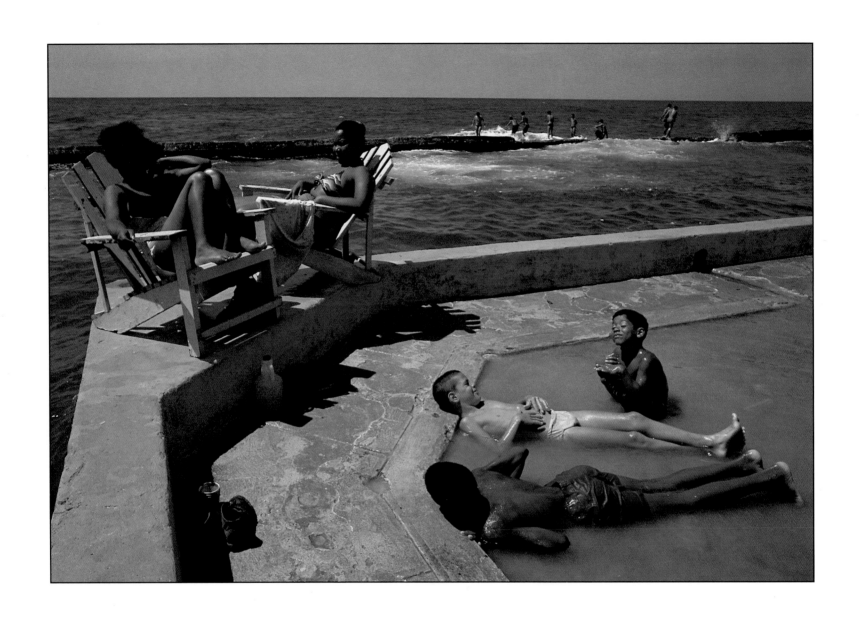

Saturday afternoon at El Coral. Havana.

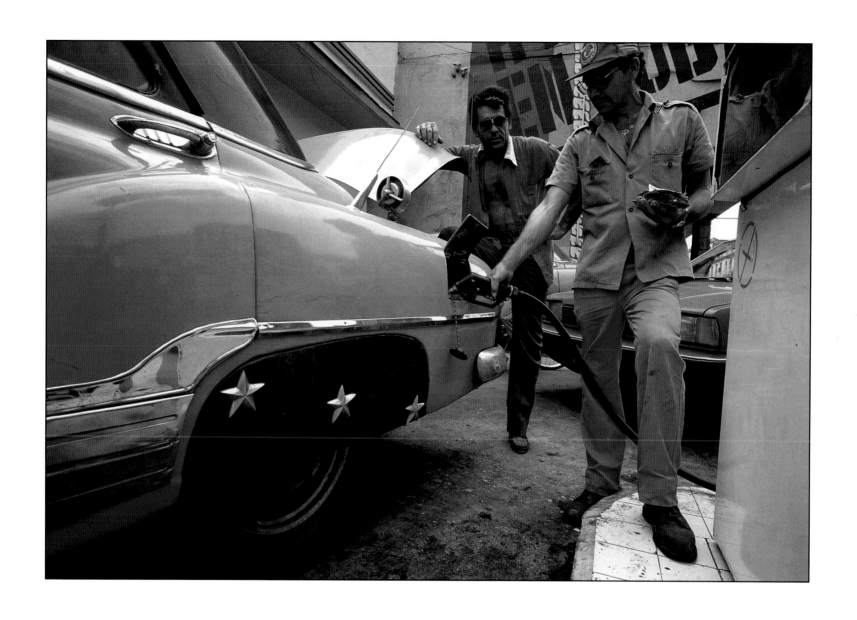

Gassing up. Each car owner is allotted about a half-tank of gas monthly. Havana.

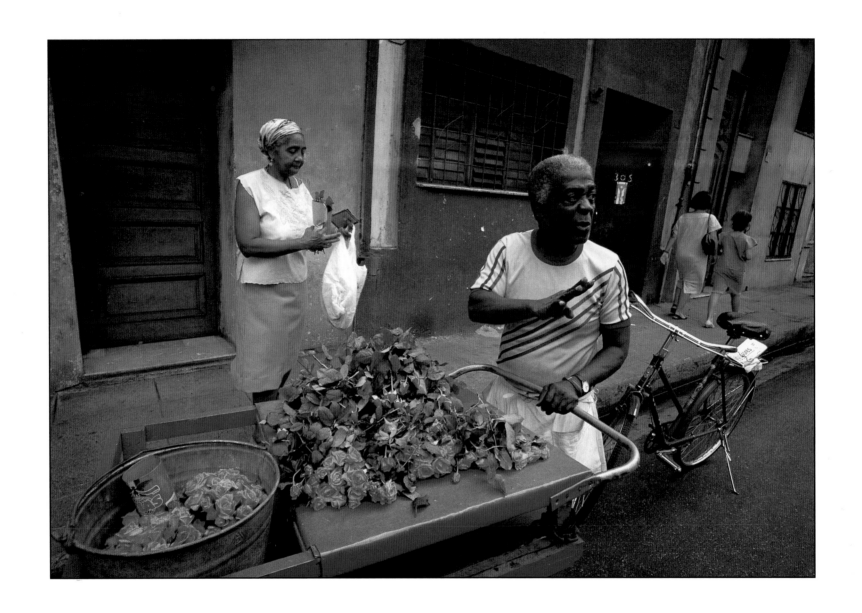

Old Havana.

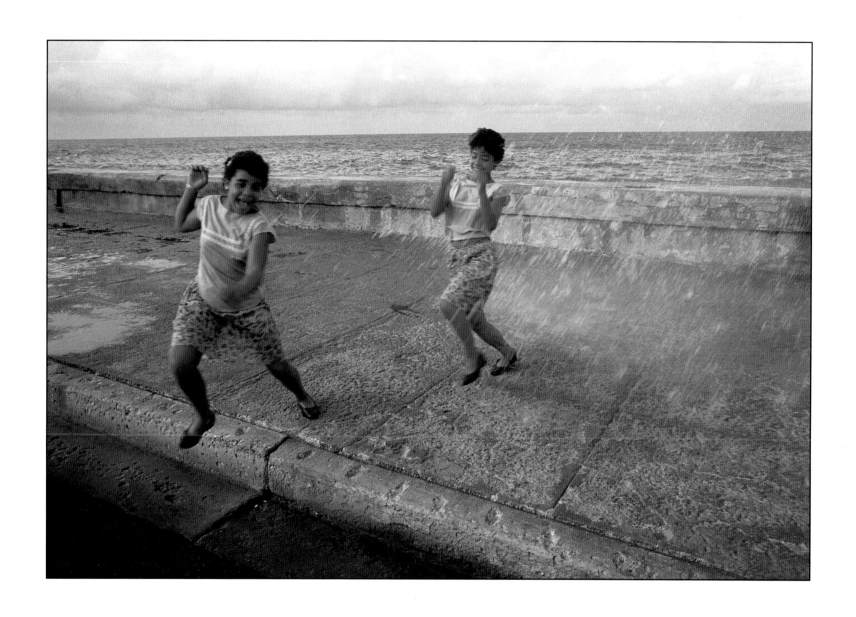

The Malecón. Havana's famous sea wall.

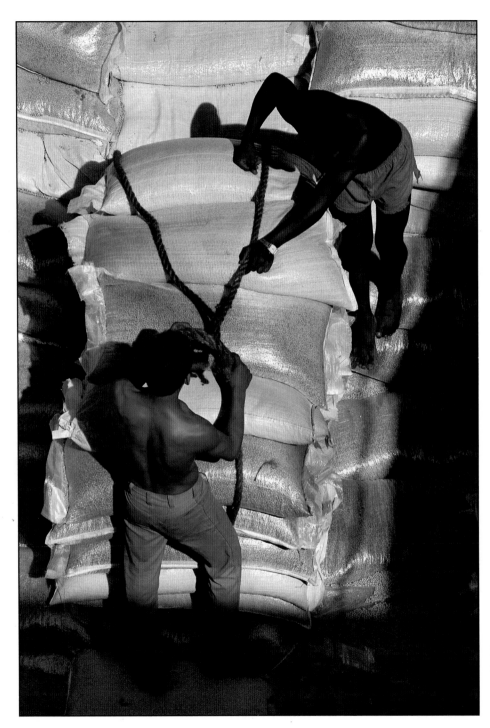

Dockworkers in the months before food shipments from Eastern Europe dried up. Havana Harbor.

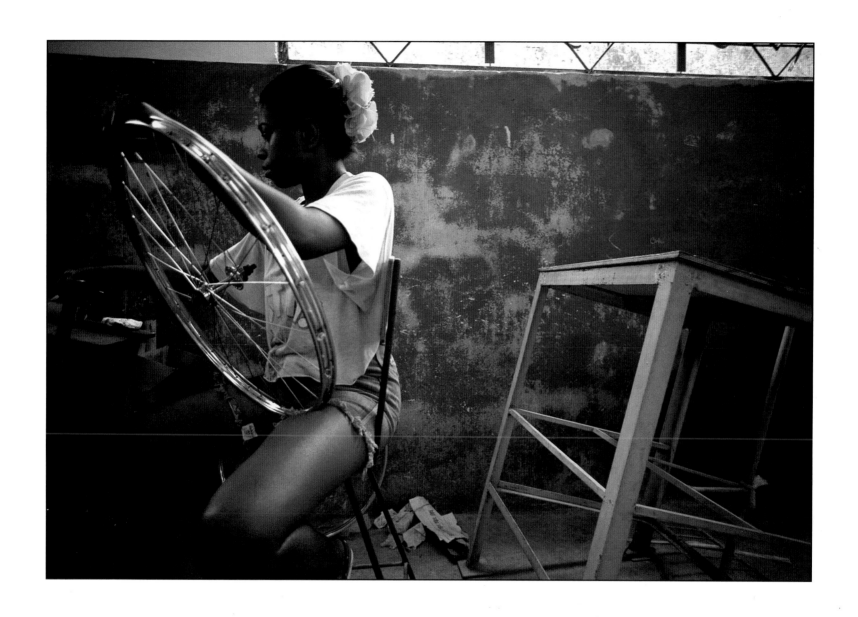

Assembling bicycles shipped from China at the Centro Polytecnico "Amnistad Cubano-Sovietco," a technical high school. Havana.

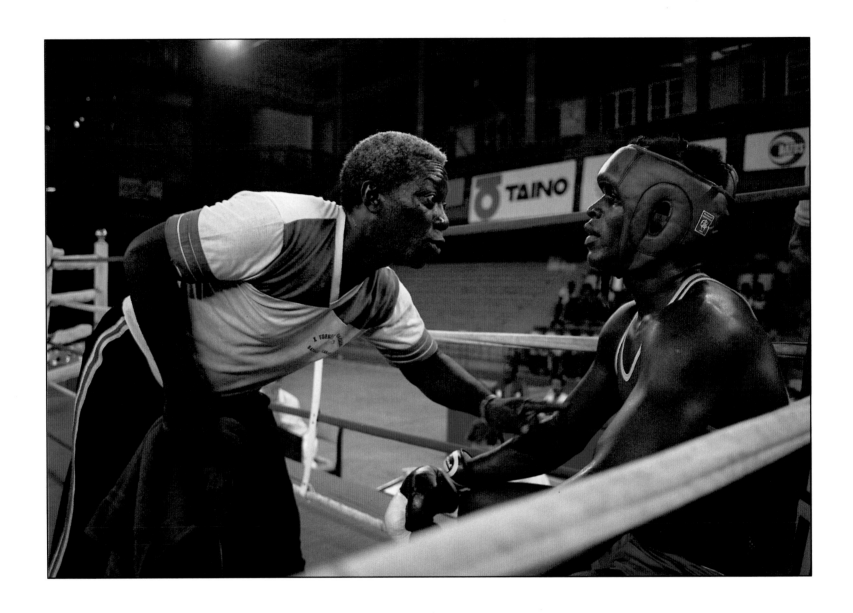

Trainer and boxer during an inter-provincial match, in preparation for the Olympics. Havana.

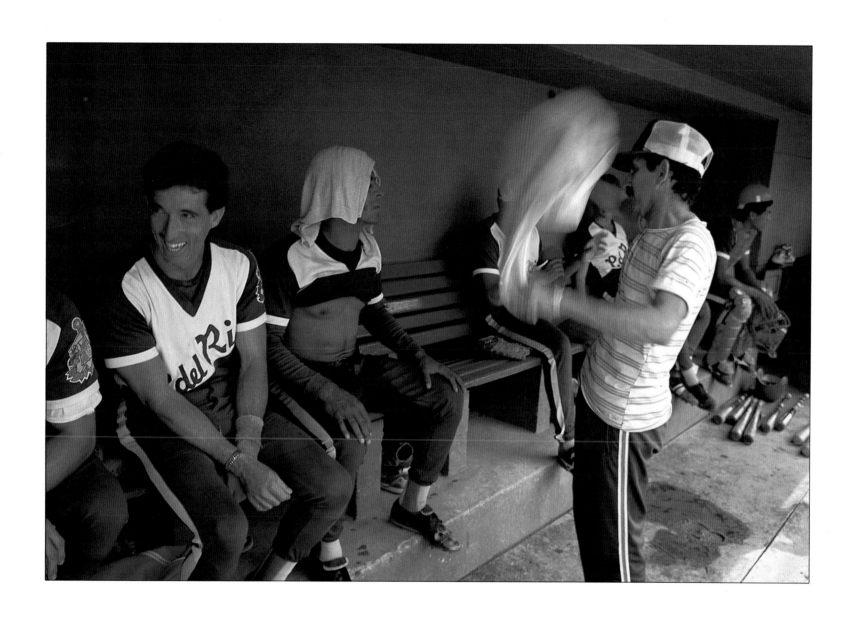

The Pinar del Río team in the dugout. Havana.

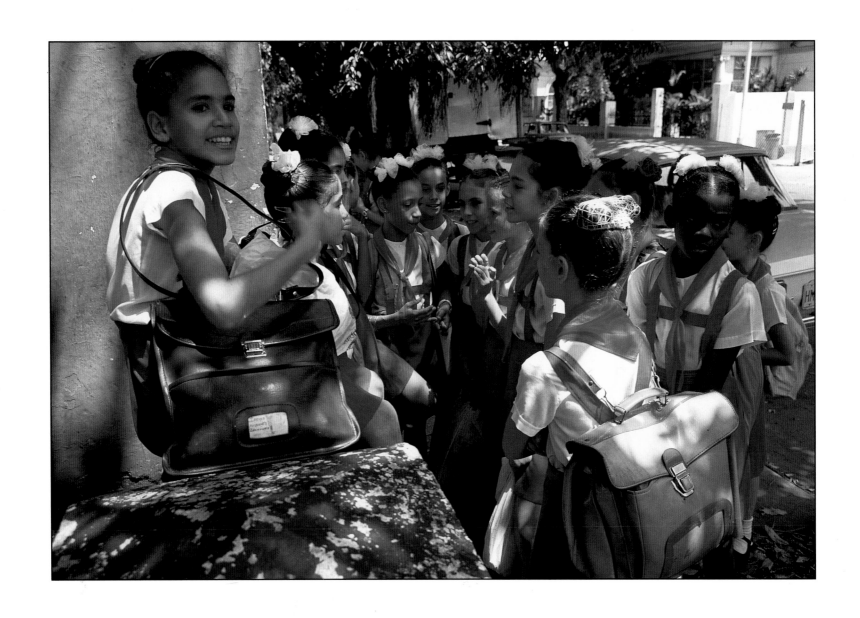

Schoolgirls waiting for their lunch. Havana.

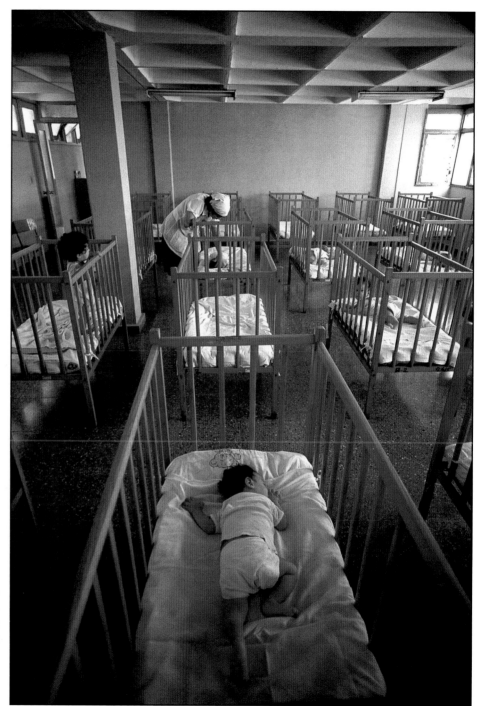

Nap time for infants at the Frank Pais Child Care Center. Open from 6AM to 7PM, Monday through Saturday, the facility cares for children from six months to five years old. The fee is a sliding scale based on the income of the parents. Havana.

Doorman at the Tropicana night club. Founded in 1939, the Tropicana was a major gambling center. Nat King Cole, Cab Calloway, and Josephine Baker all performed there in prerevolutionary days. The stage show now has a cast of 150 along with a thirty-two-piece orchestra and is a major source of foreign exchange currency. Havana.

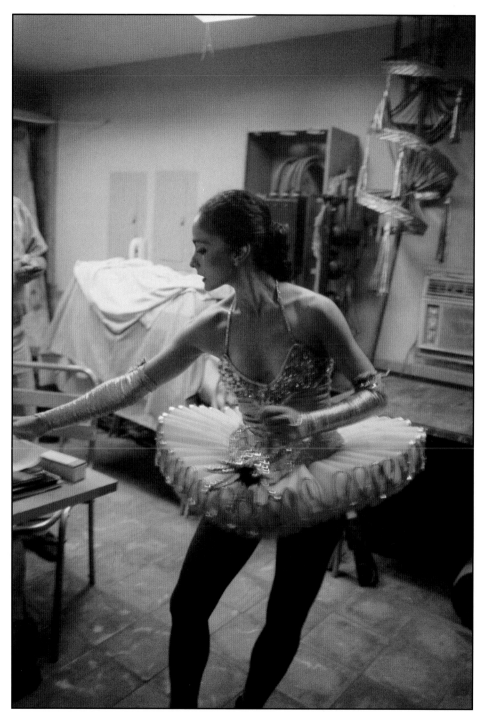

Backstage. The Tropicana. Havana.

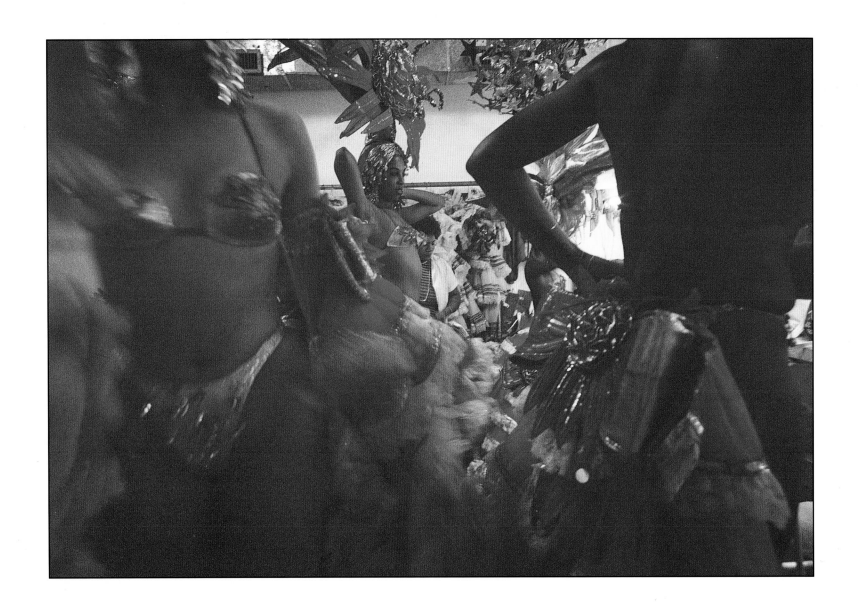

The dressing room. The Tropicana. Havana.

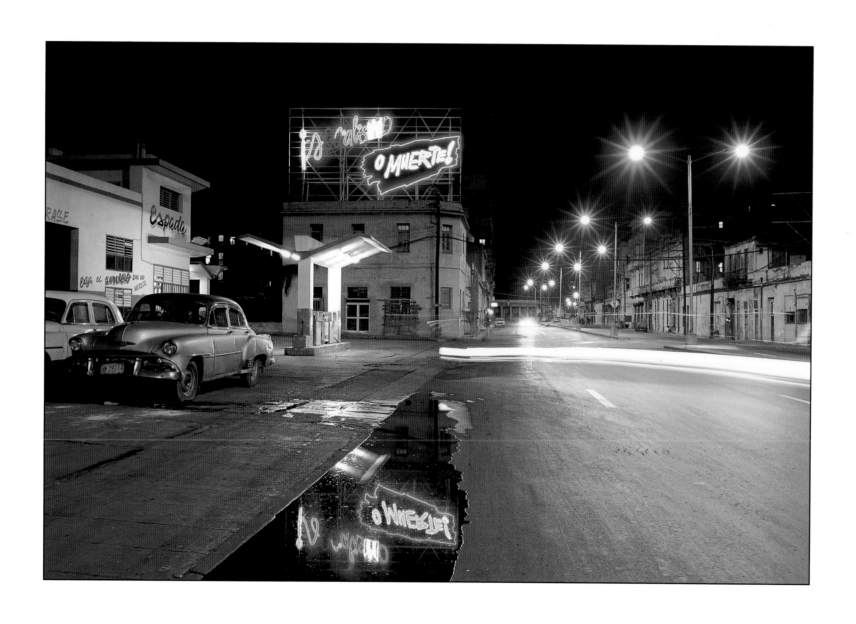

Neon sign reads "Socialism or Death." Havana.

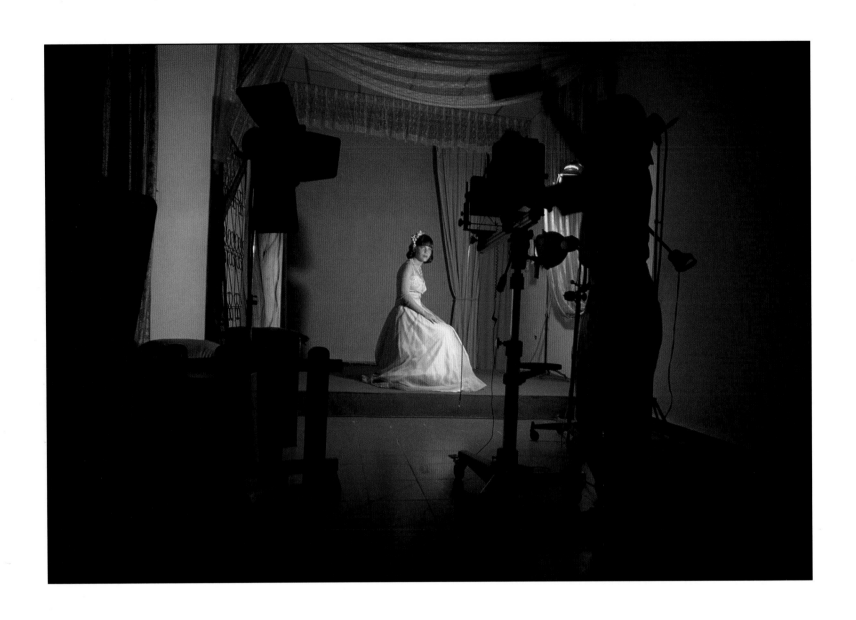

A *habanera* has her portrait taken for her traditional fifteenth birthday festivities. Central Havana.

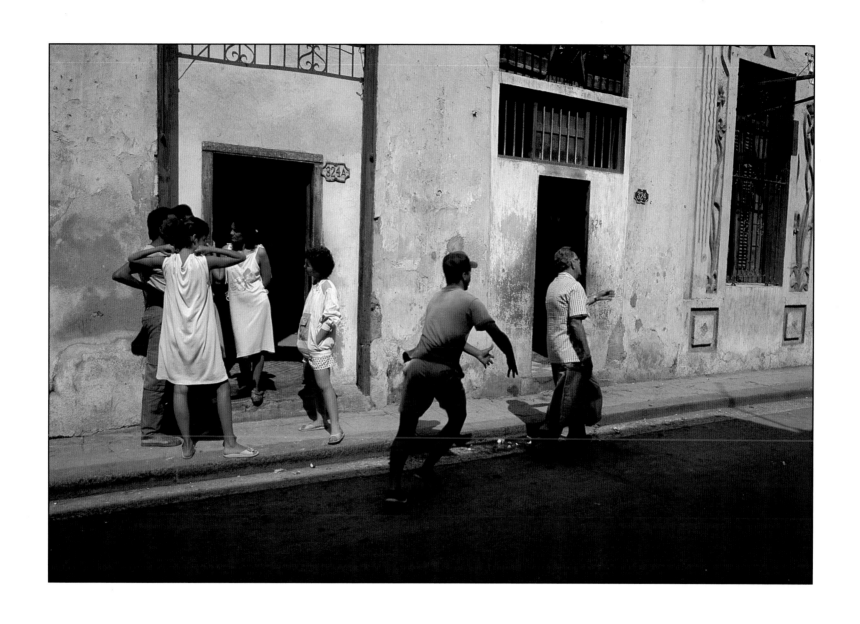

Sunday morning. Old Havana.

67

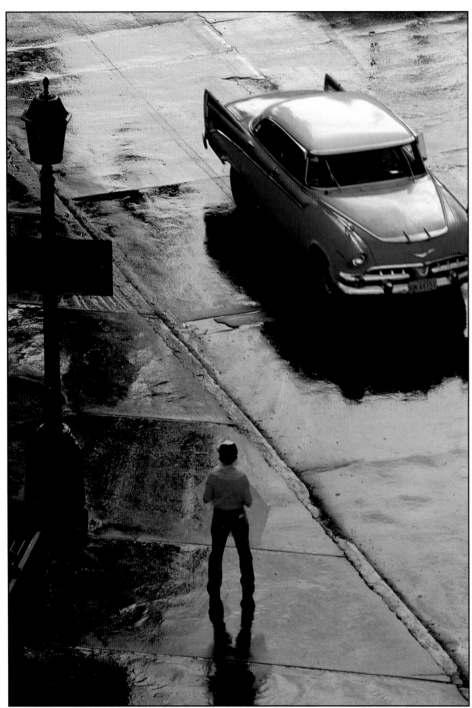

Opposite: A tropical downpour. Parque Central. Havana.

Waiting for a bus. Vedado, Havana.

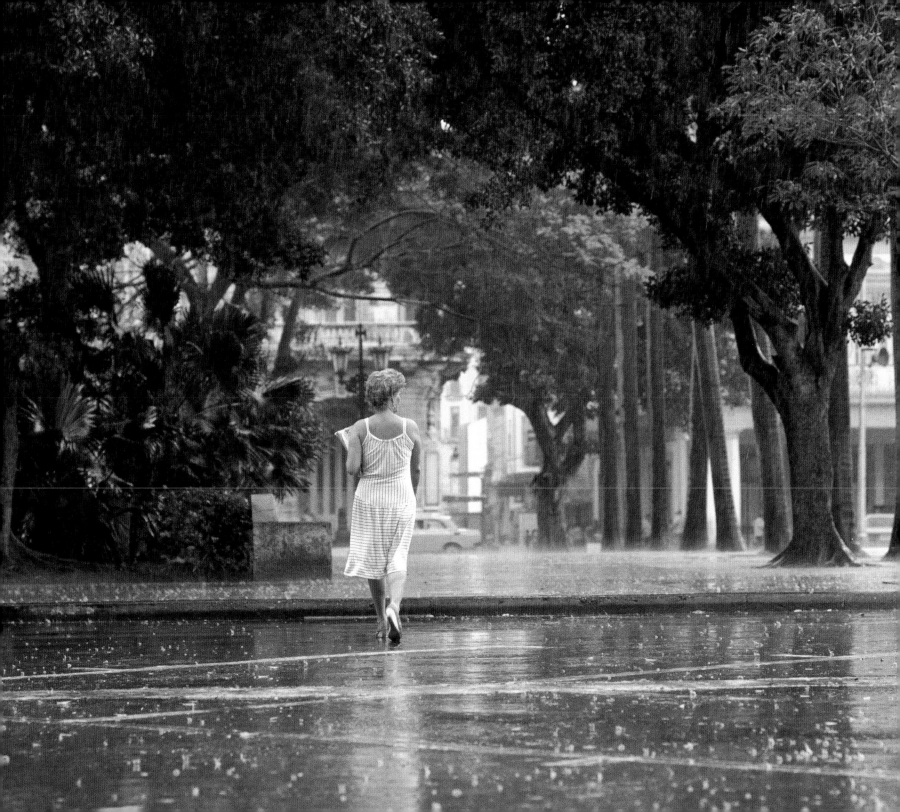

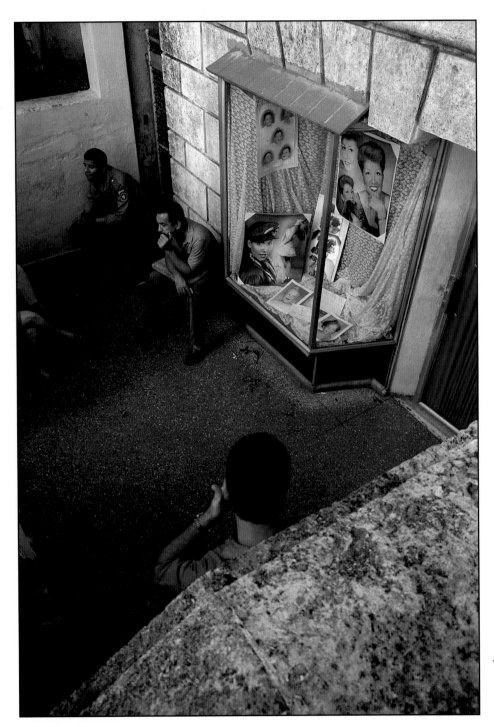

Waiting outside of a photography studio. Havana.

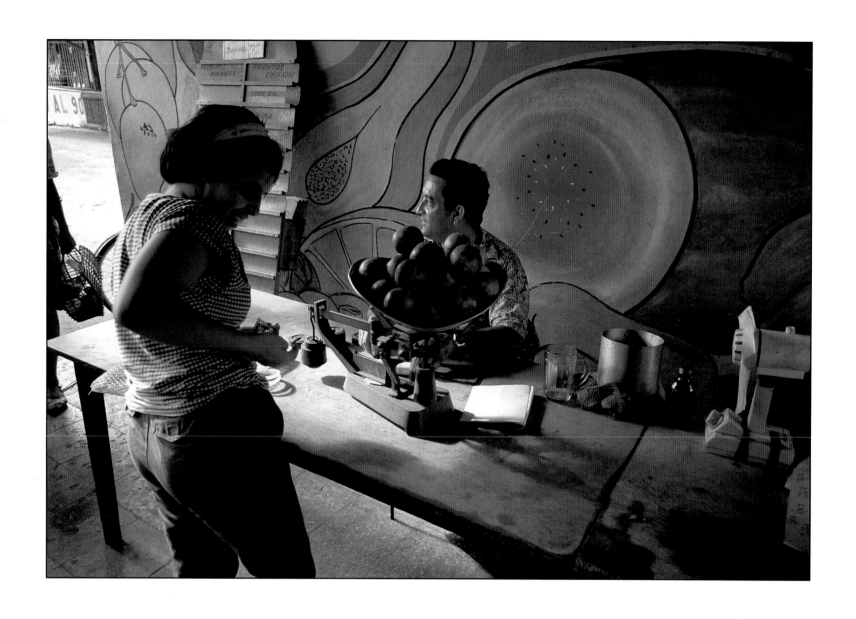

Produce for sale. Nueva Gerona, Isle of Youth.

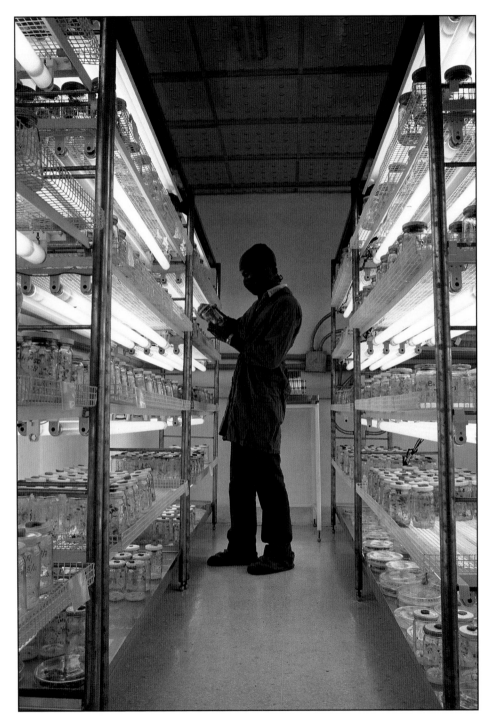

National Center for Biotechnology and Genetic Engineering. Scientists here have developed vaccines for meningitis B and hepatitis B, pioneered work with interferon, and developed an inexpensive AIDS testing kit. Havana.

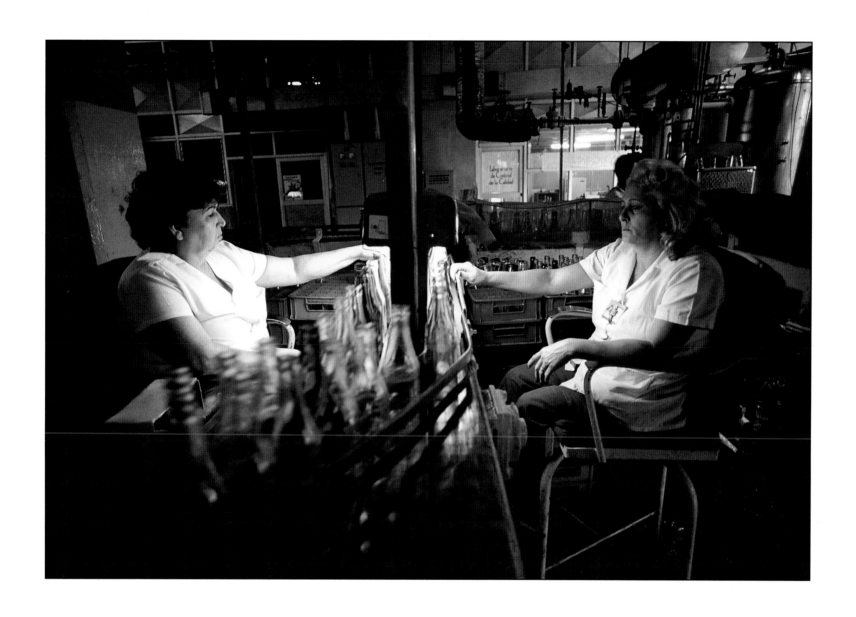

Tropicola Bottling Plant, founded originally in 1946 as Canada Dry. Havana.

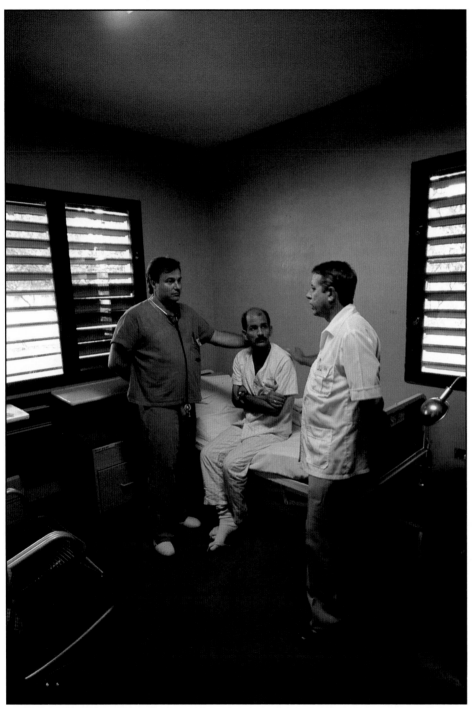

The Santiago de Las Vegas Sanatorium, an AIDS clinic where treatment, housing, and meals are provided free of cost. Havana.

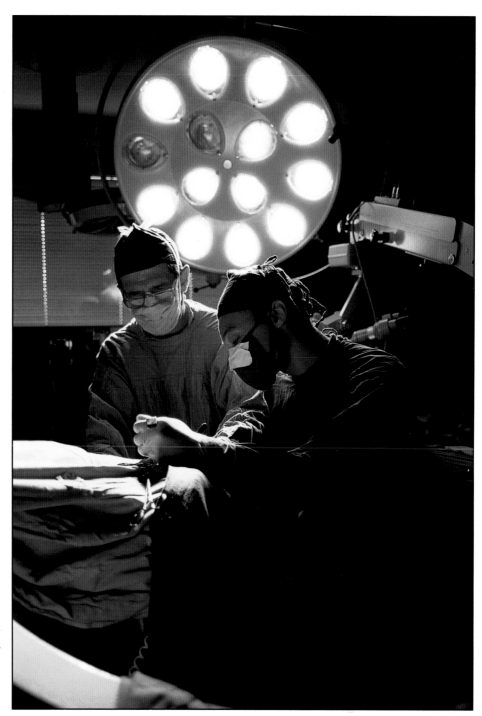

Farmer undergoes complex microsurgery at Hermanos Almeijeras Hospital. All health care in Cuba is free of cost. Havana.

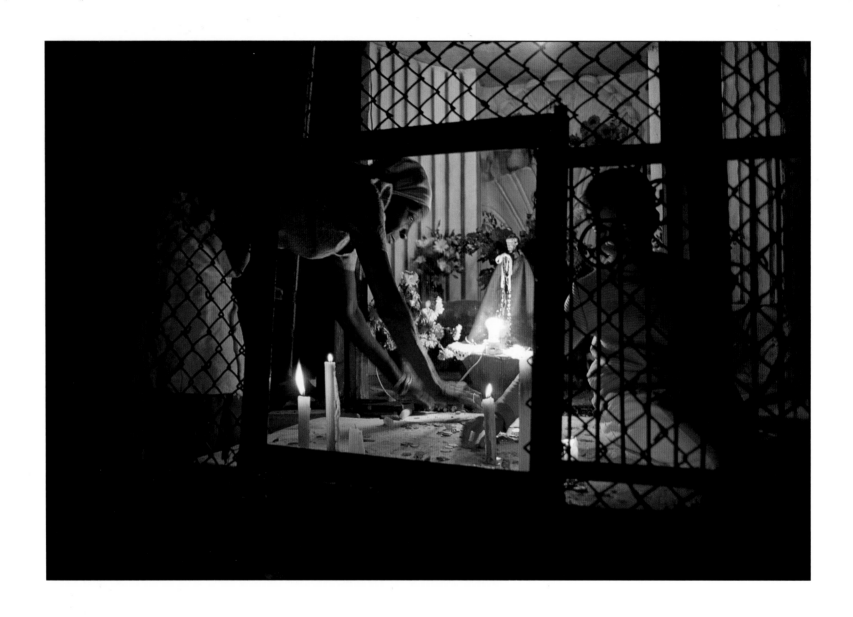

Altar honoring San Lazaro, a deity in Afro-Cuban Santería. Havana.

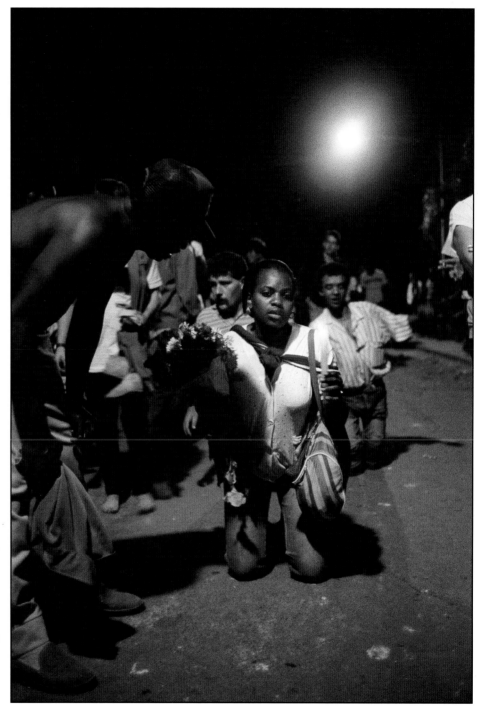

Pilgrimage on San Lazaro's Day to El Rincon. Outside Havana.

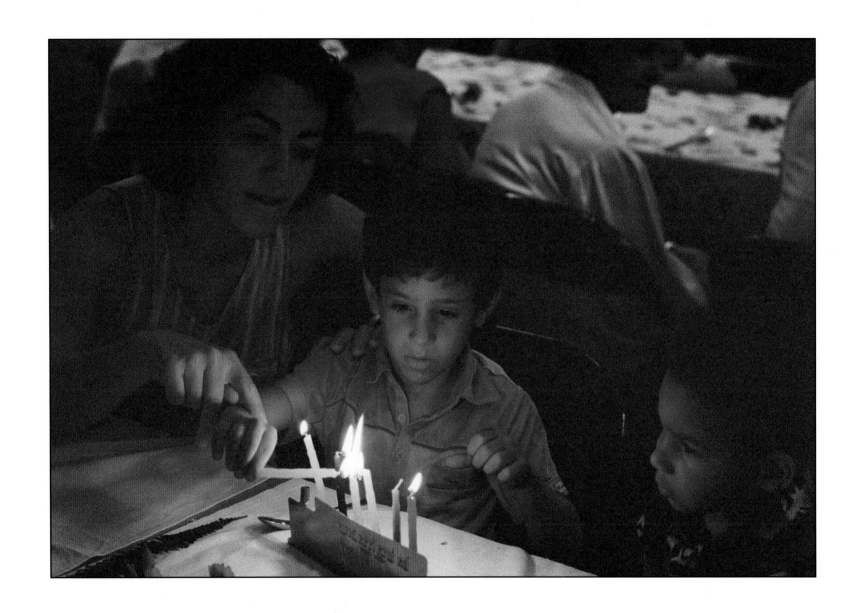

Lighting the Chanukah menorah at one of the two active synagogues in Havana.

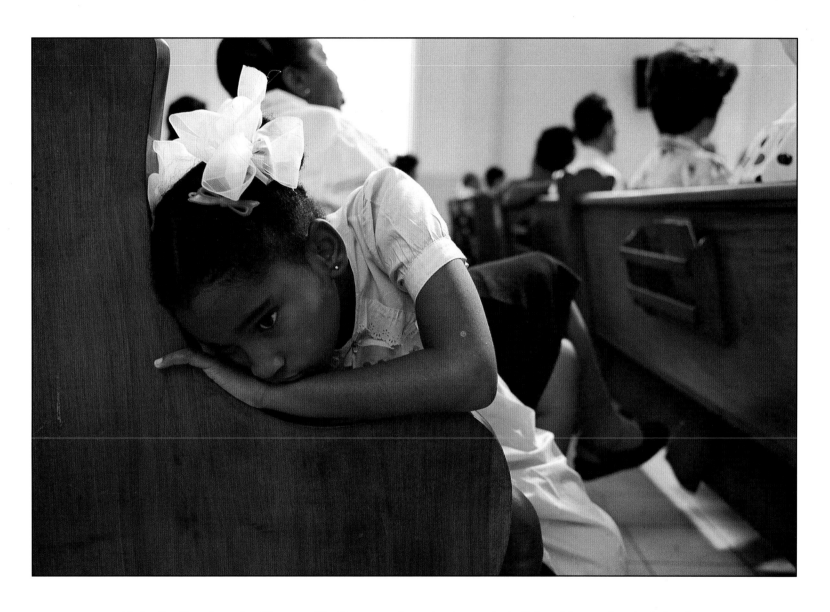

Methodist Church service. There are fifty Protestant denominations active in Cuba with seven-hundred churches and six-hundred chapels, pastoral houses, and missions nationwide. Baptists are the largest with fifteen-thousand members, followed by the Methodists with four-thousand churchgoers. Havana.

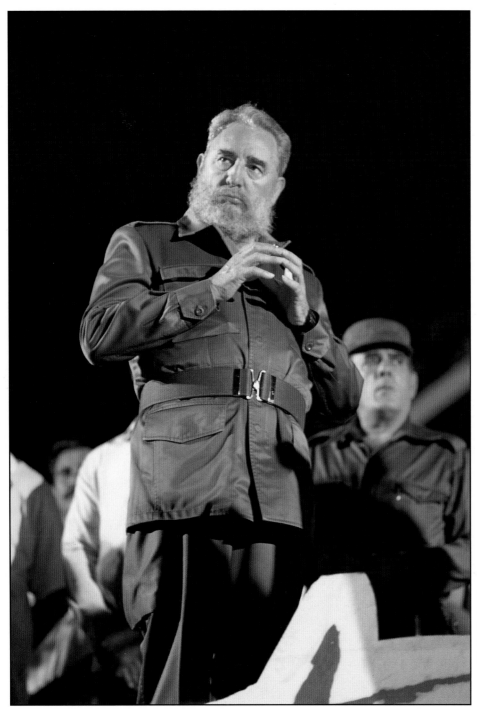

President Fidel Castro listening to a speech by Communist Youth leader Roberto Robaina at the rally marking the anniversary of the Pioneer Children's Organization and the Union of Young Communists. Havana.

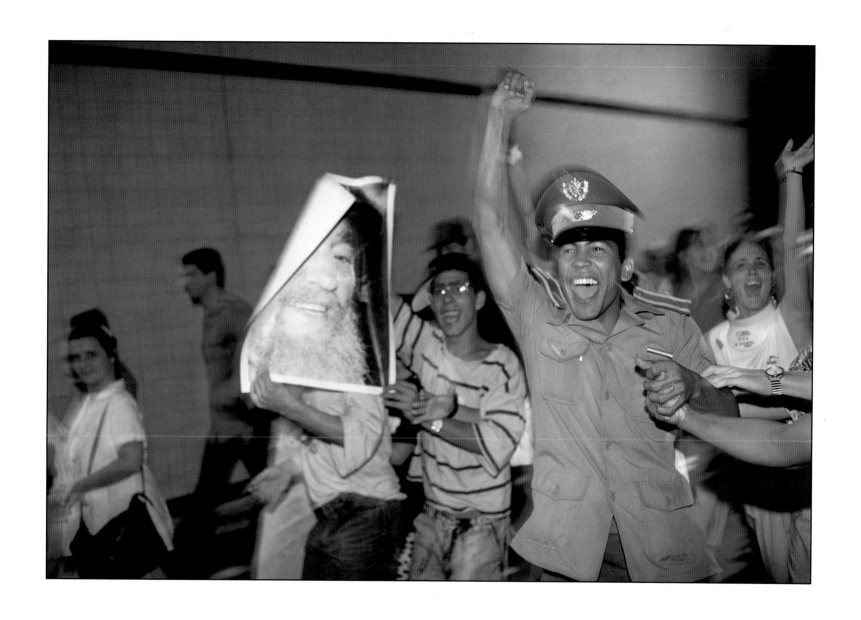

Young people demonstrate their support for the government during a Cuba Va march. Havana.

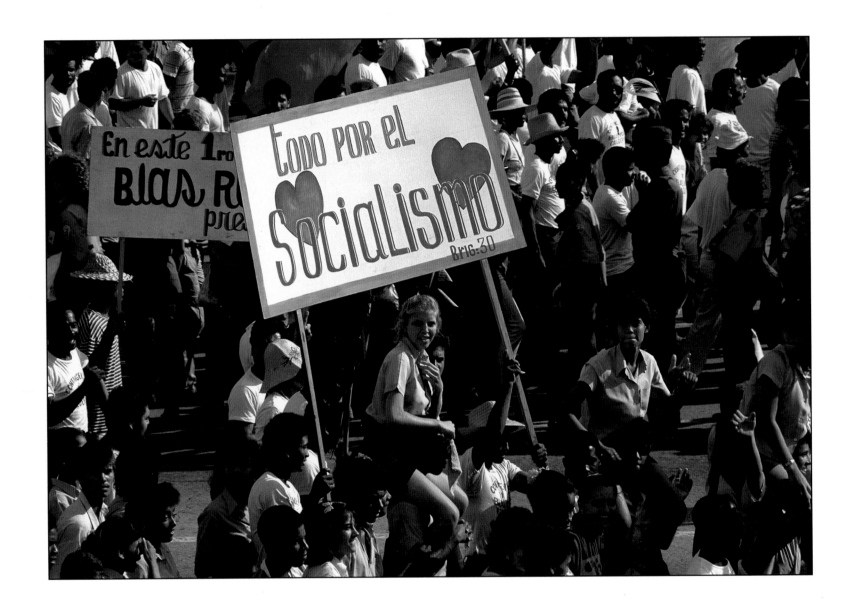

One million Cubans turn out for International Workers' Day on May Day. Sign reads "Everything for Socialism."
Havana.

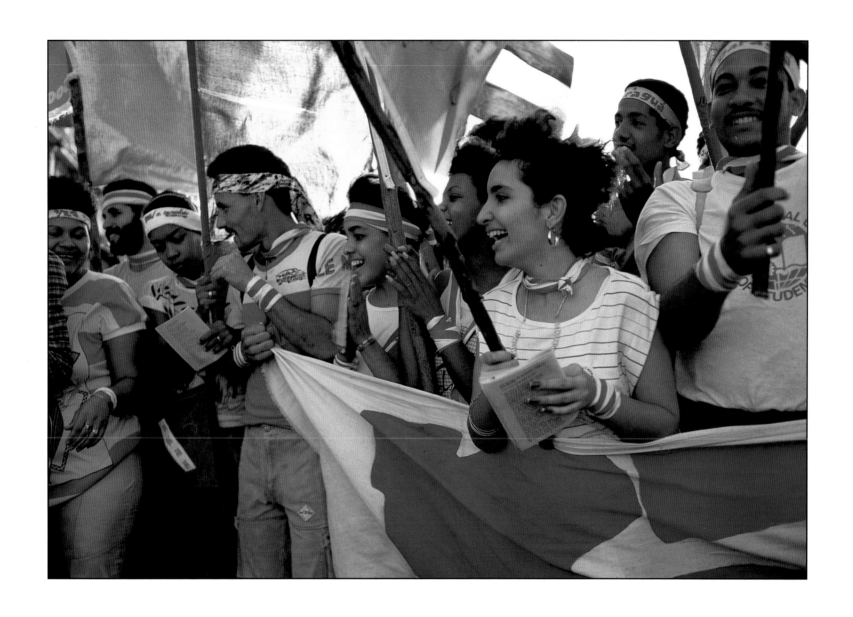

Youth pro-government demonstration. Havana.

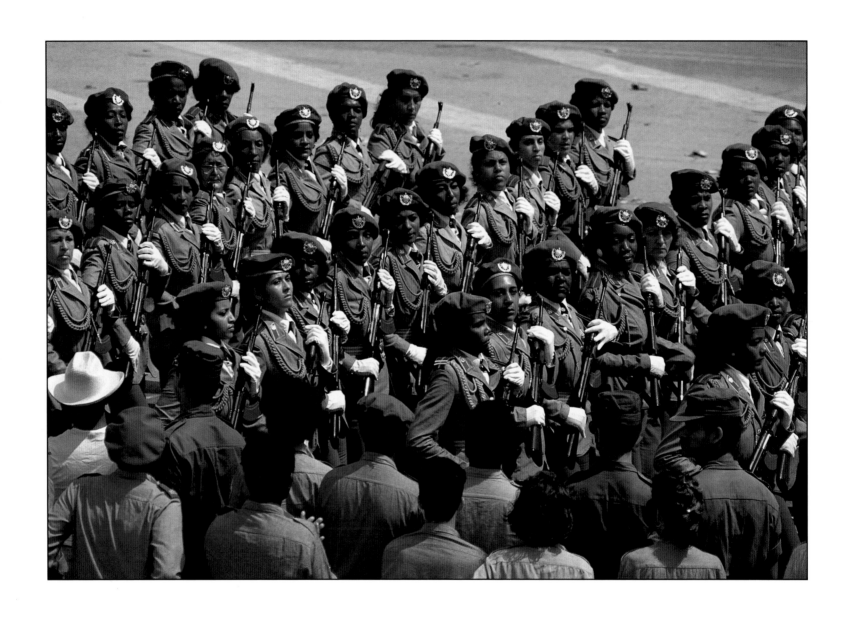

Militia women march on May Day. Havana.

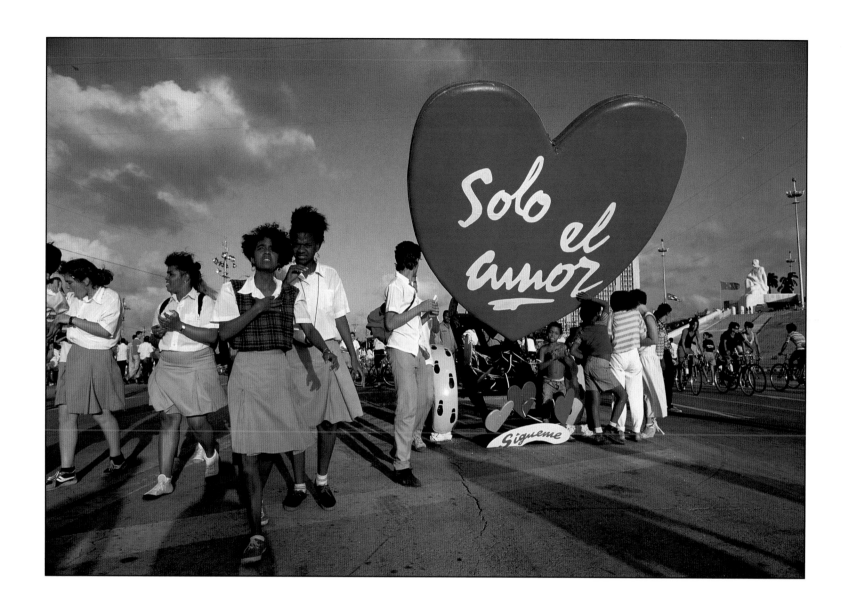

Waiting for the rally to begin at the Plaza de la Revolución; statue of José Martí in background. Float reads, "Only Love." Havana.

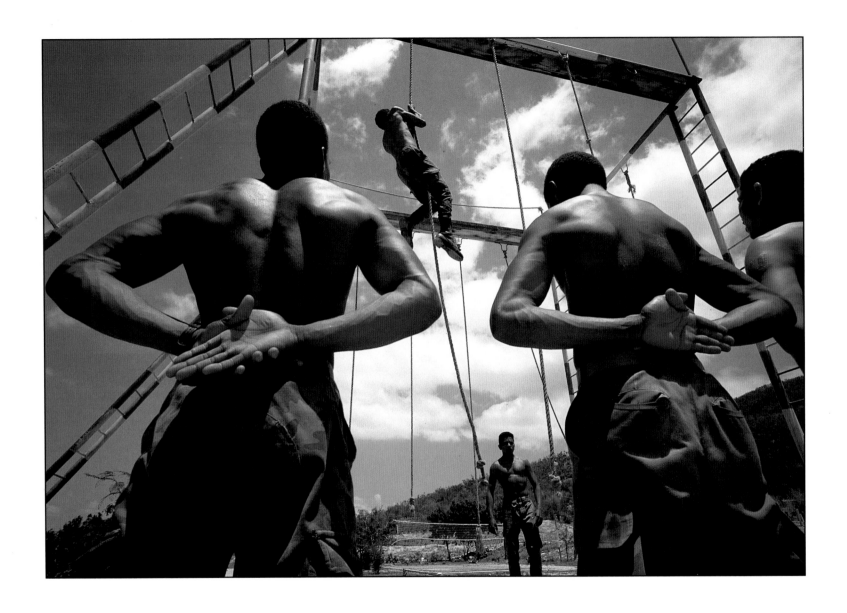

Cuban border guards in training near the U.S.'s Guantánamo Naval Base, the result of a treaty signed at the turn of the century.

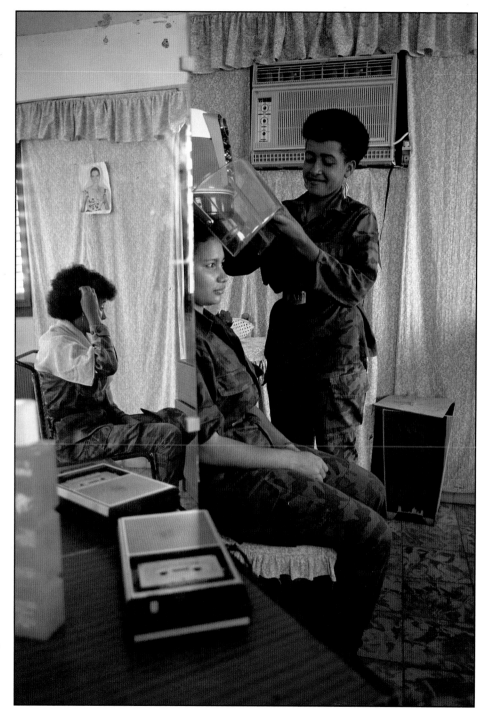

Cuban border guards at the base beauty parlor.
Guantánamo.

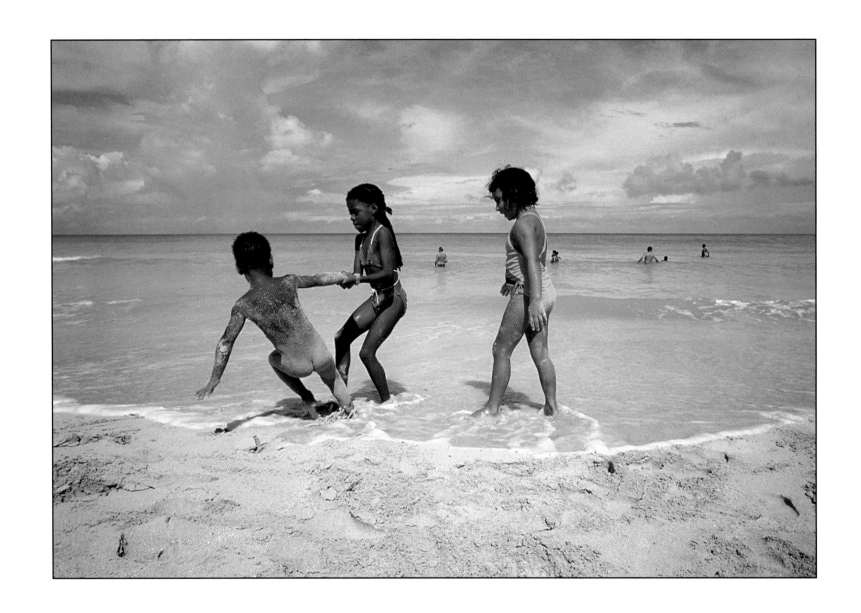

Varadero Beach.

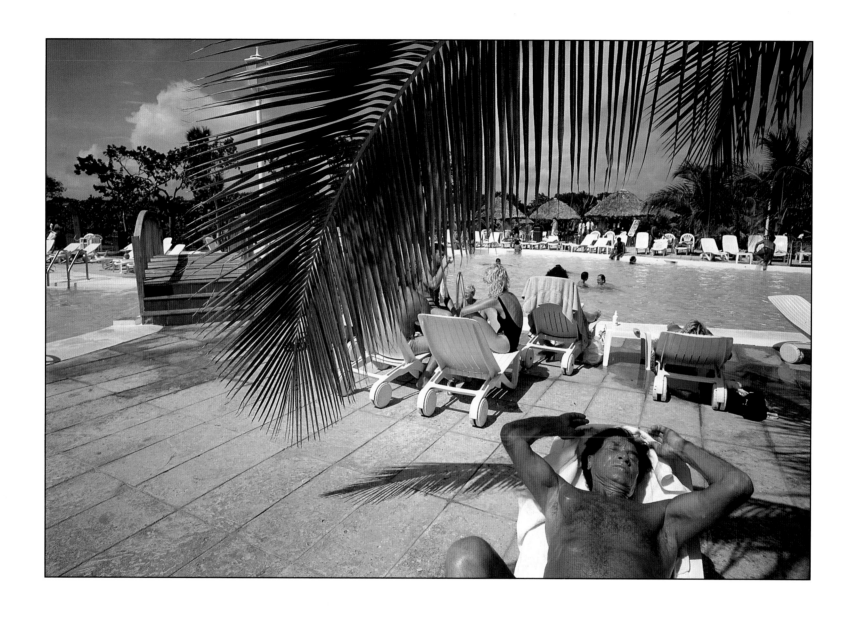

Tourists poolside at the Sol Palmeras Hotel, jointly owned by Cuban and Spanish investors. Varadero Beach, Matanzas.

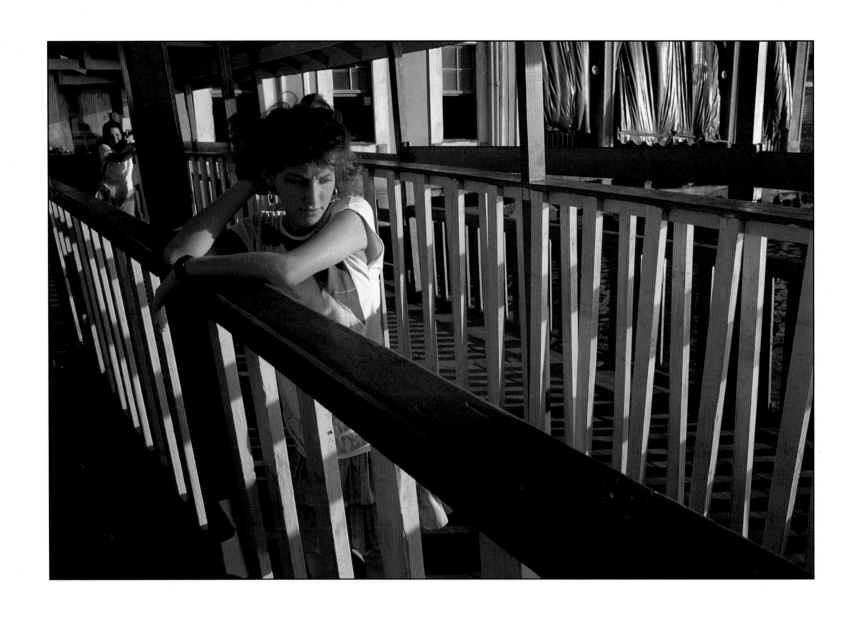

Waiting for the ferry to cross the bay to Havana. Regla.

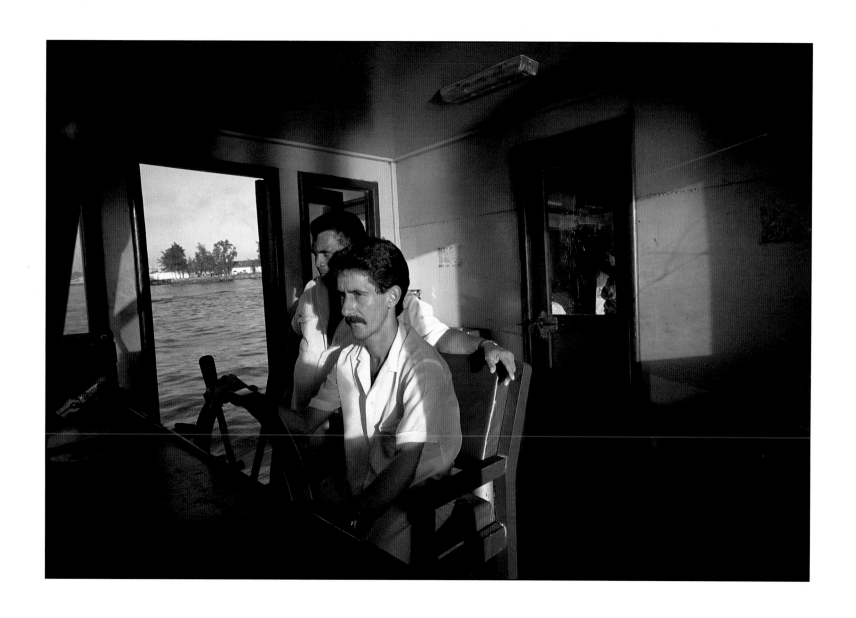

Ferry boat captain. Havana Bay.

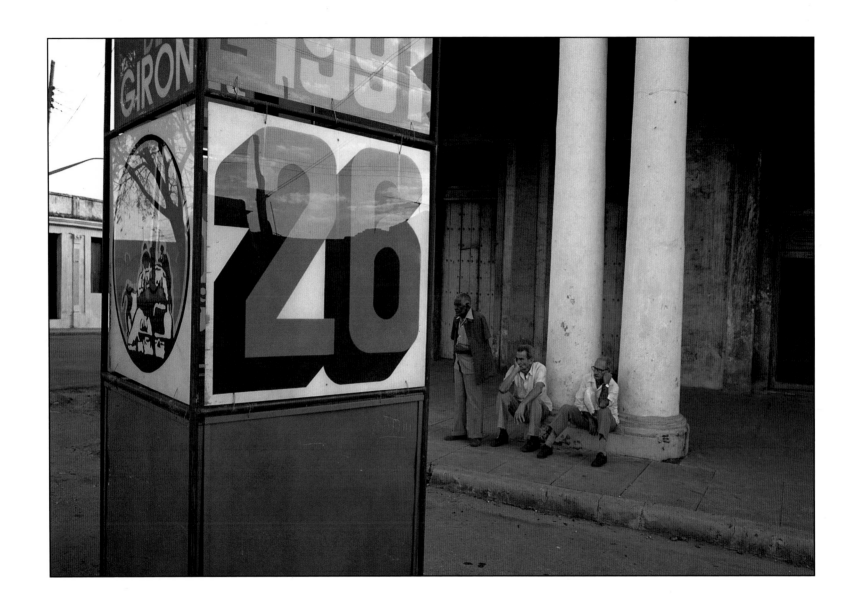

Street sign commemorating the 1961 battle of Playa Girón (Bay of Pigs), when U.S.-led forces were defeated, and the 1953 attack on the Batista dictatorship's Moncada barracks. Matanzas.

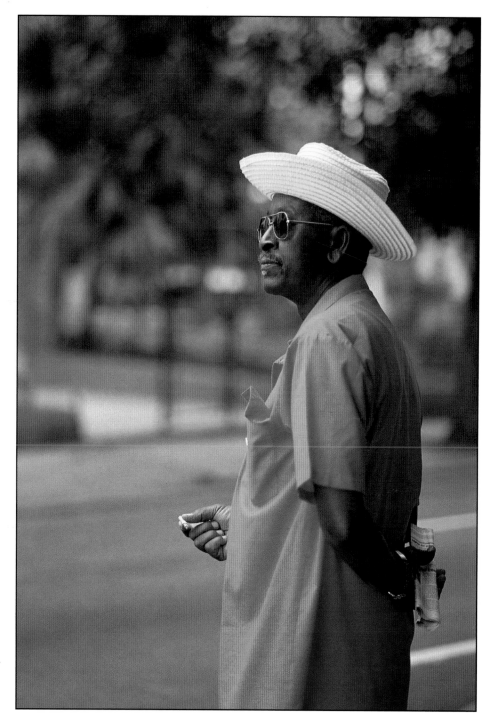

Habanero at a bus stop. Havana.

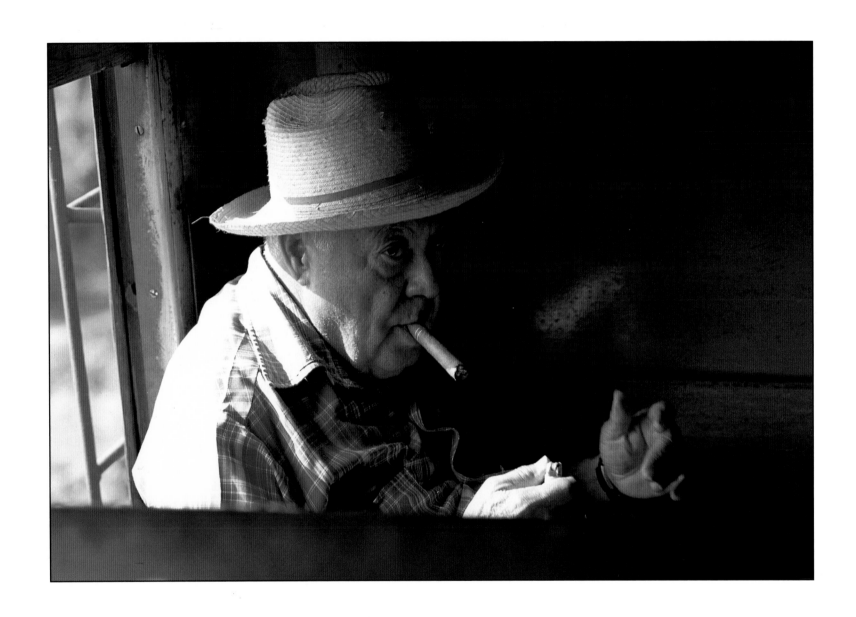

On the train to Matanzas from Havana.

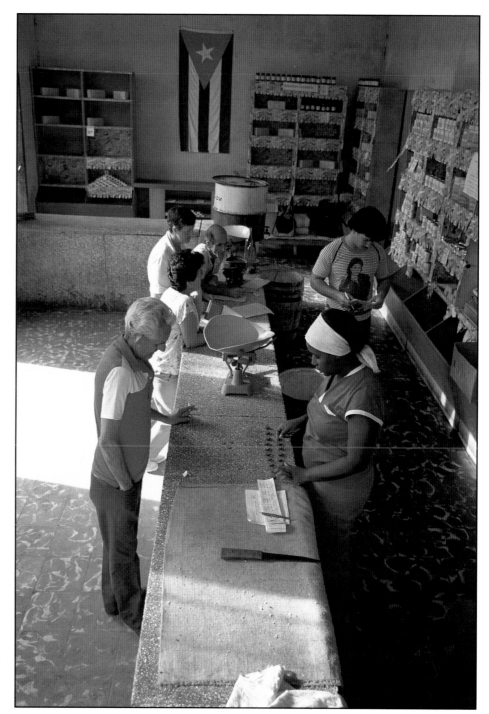

Dry goods store. Matanzas.

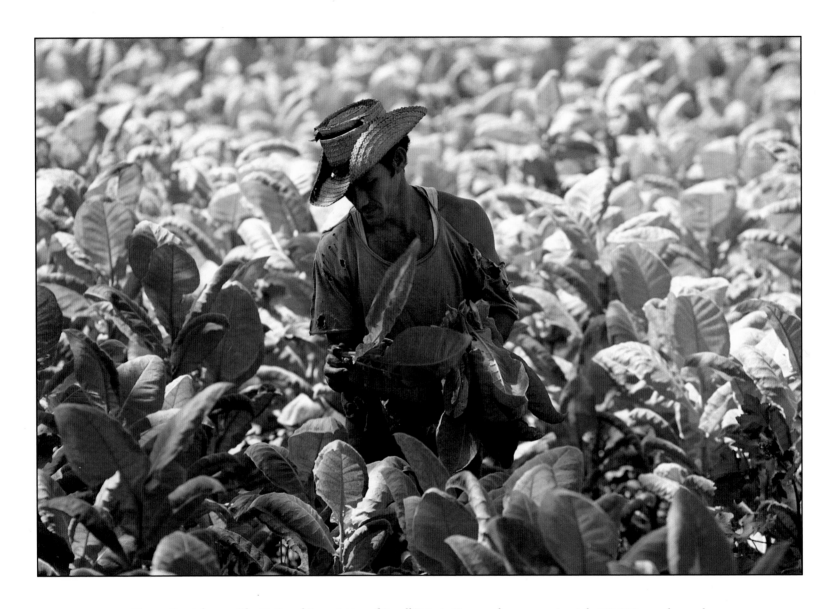

Harvesting tobacco. The National Association of Small Private Farmers has approximately 185,000 members who account for 70 percent of the country's tobacco production. The state sets prices in consultation with the farmers and purchases the crop. Viñales Valley, Pinar del Río.

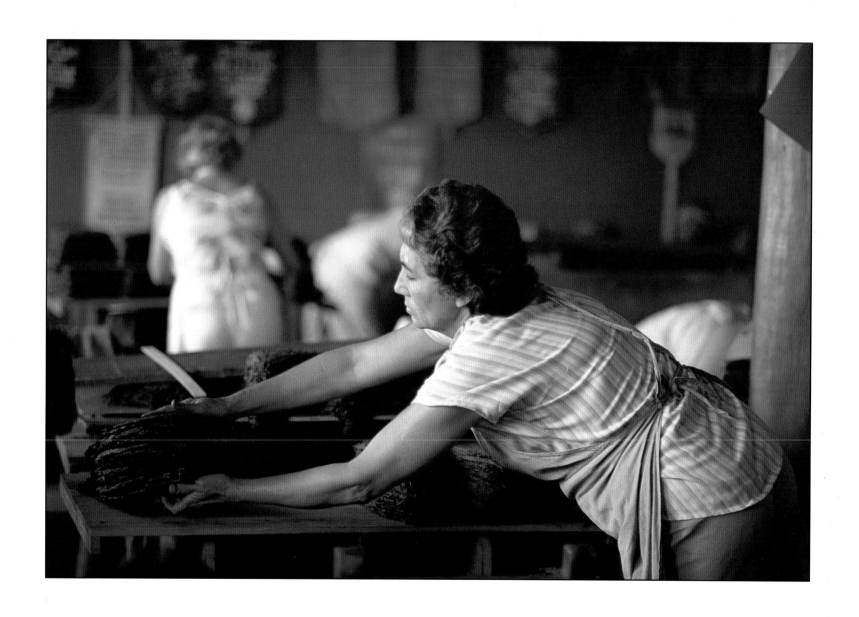

Grading tobacco leaves at a cigar factory. Viñales Valley, Pinar del Río.

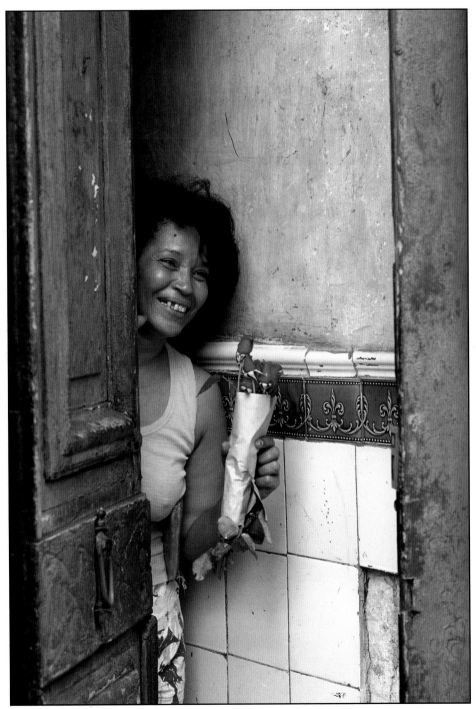

Havana.

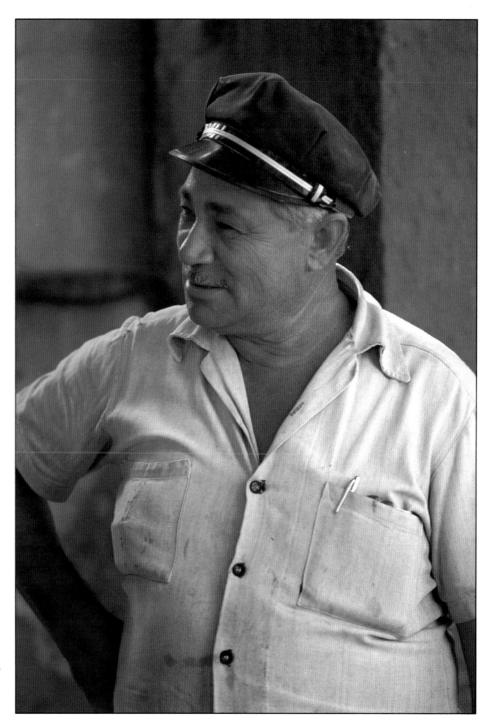

Bus Driver. Nueva Gerona.

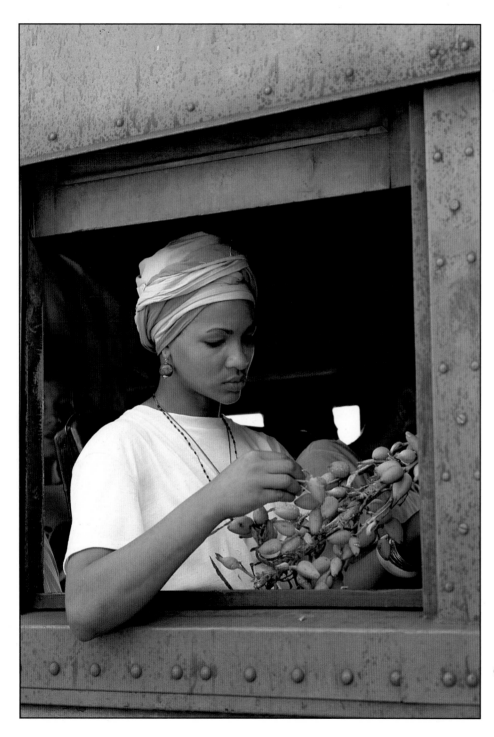

On the train from Matanzas to Havana.

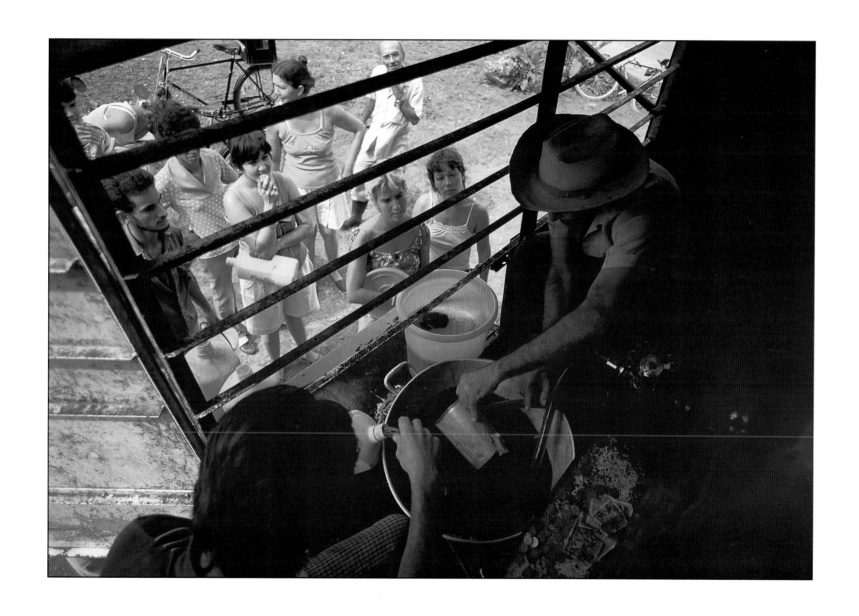

Rural Cubans buy soda from tailgate vendors. Melena del Sur, Havana.

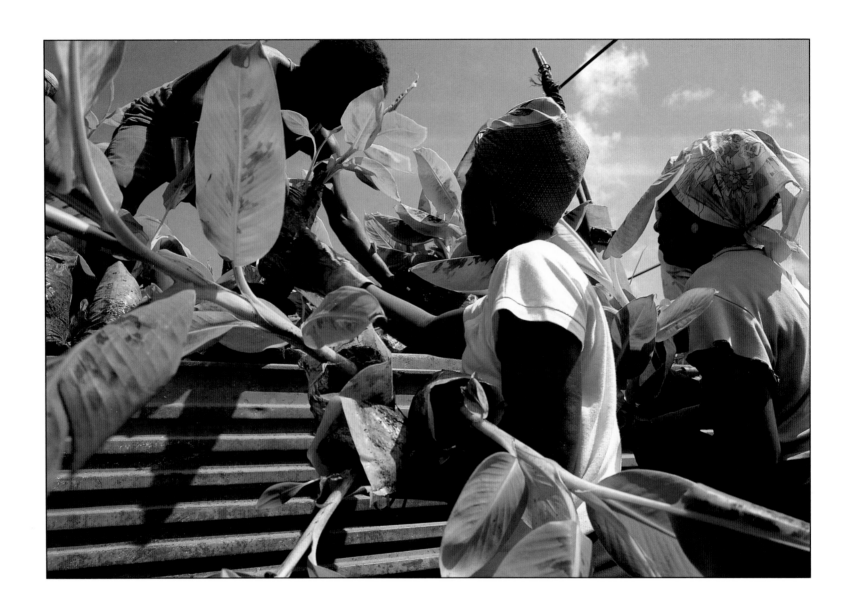

Agricultural brigade planting bananas. Güines, Havana.

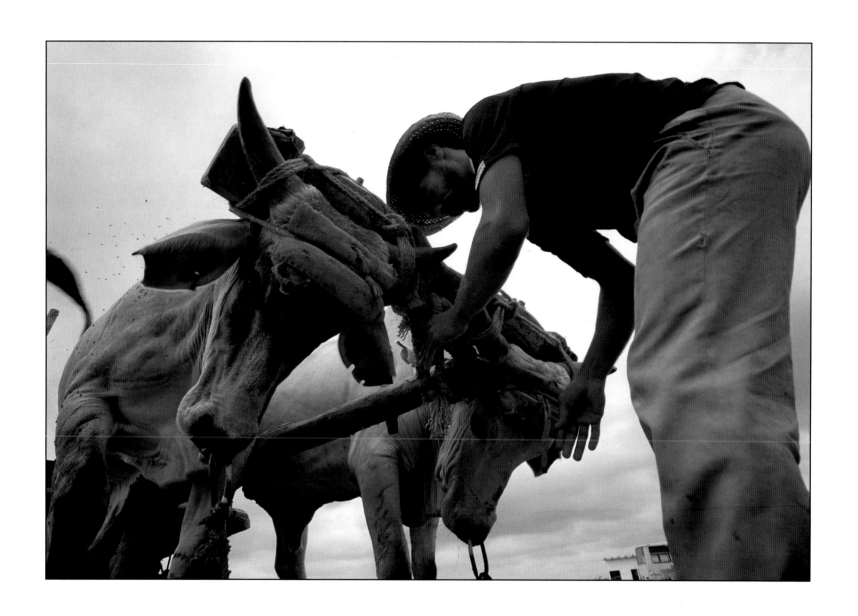

Due to the fuel shortages, oxen-drawn plows and carts replace tractors. Melena del Sur, Havana.

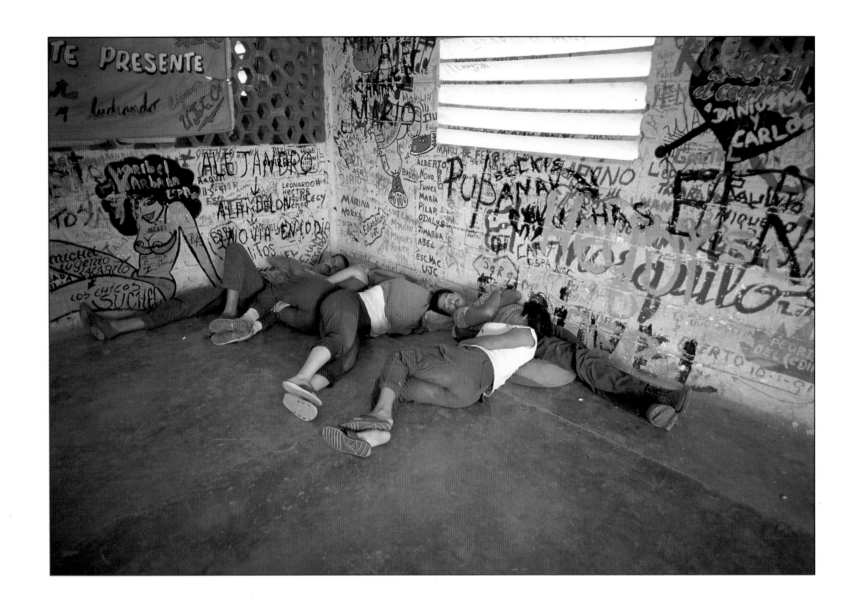

Youth farm volunteers take a break at an agricultural camp. Young city-dwellers make a two-year commitment to work here as part of Cuba's efforts to boost domestic food production. Melena del Sur, Havana.

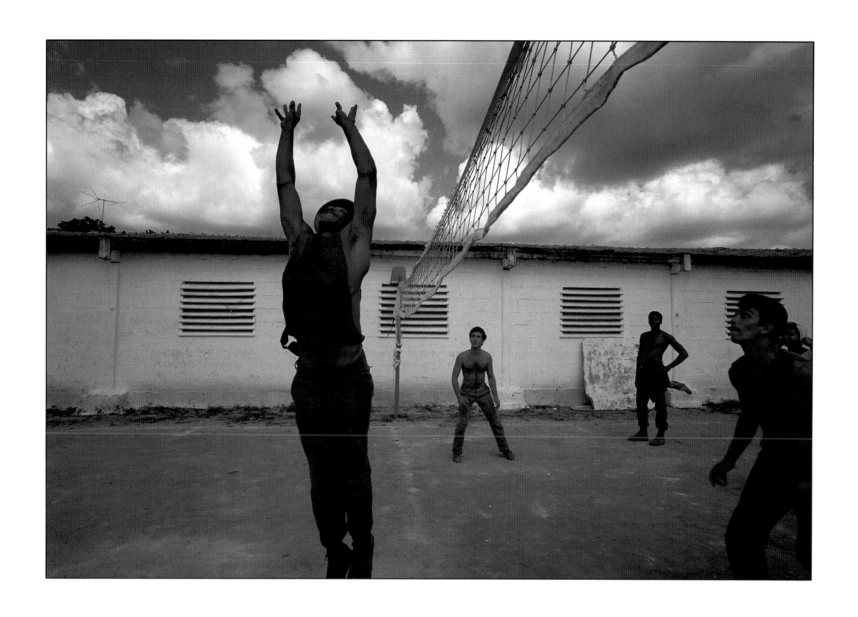

Volleyball game during the lunch break. Havana.

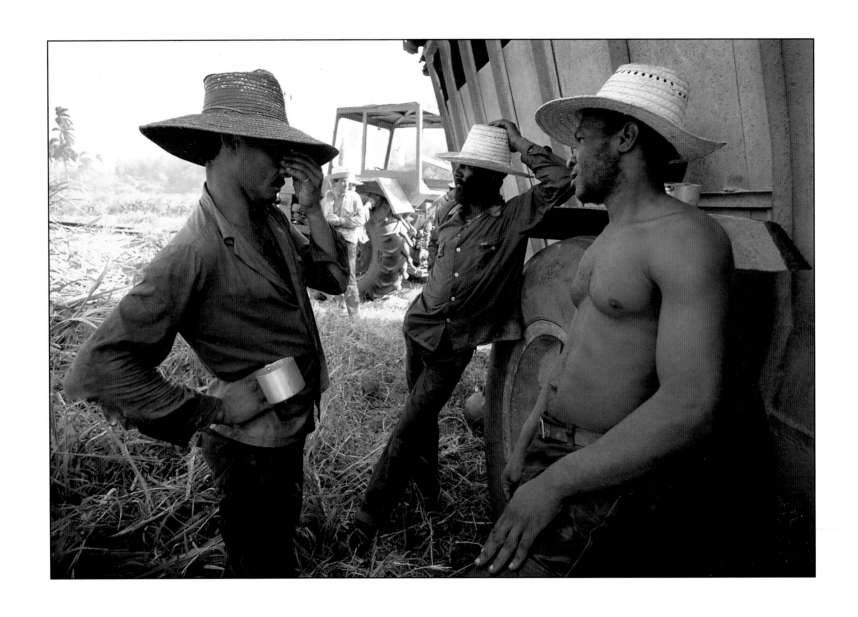

Cane cutters. Sugar was the mainstay of the Cuban economy before the price of sugar hit rock bottom on the world market. Santa Cruz del Norte, Havana.

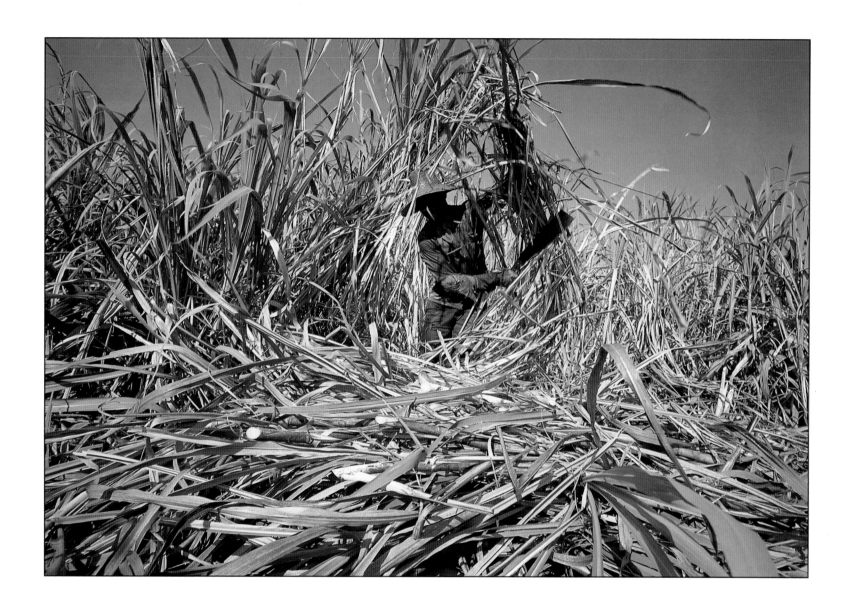

Cutting sugar. A cane cutter can make up to five-hundred pesos a month, equal to the salary of a doctor, although harvesting by machines is becoming more prevalent. Santa Cruz del Norte, Havana.

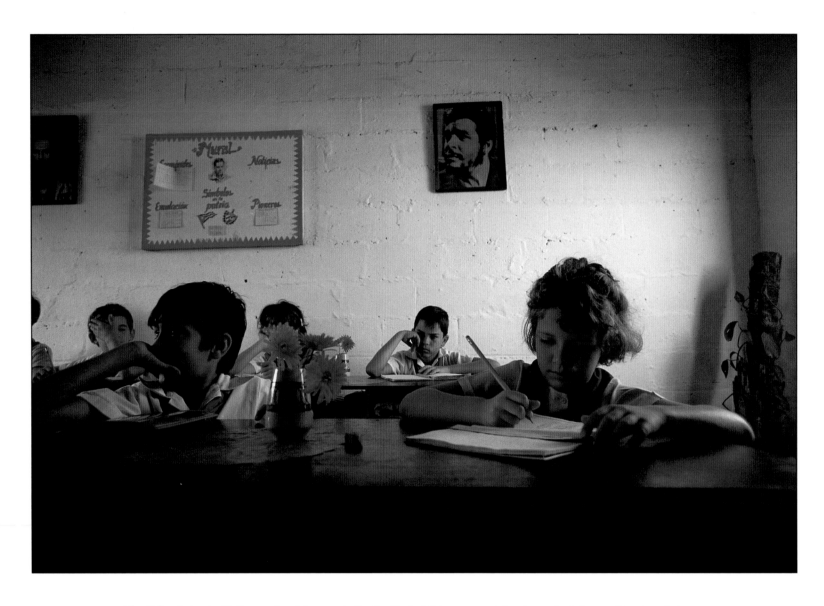

The Julio Antonio Mella, a school for mentally disabled children ages eight through eighteen. No class is larger than eight students. In 1992 the school won five medals at the Special Olympics in Indianapolis, Indiana. Santa Cruz del Norte, Havana.

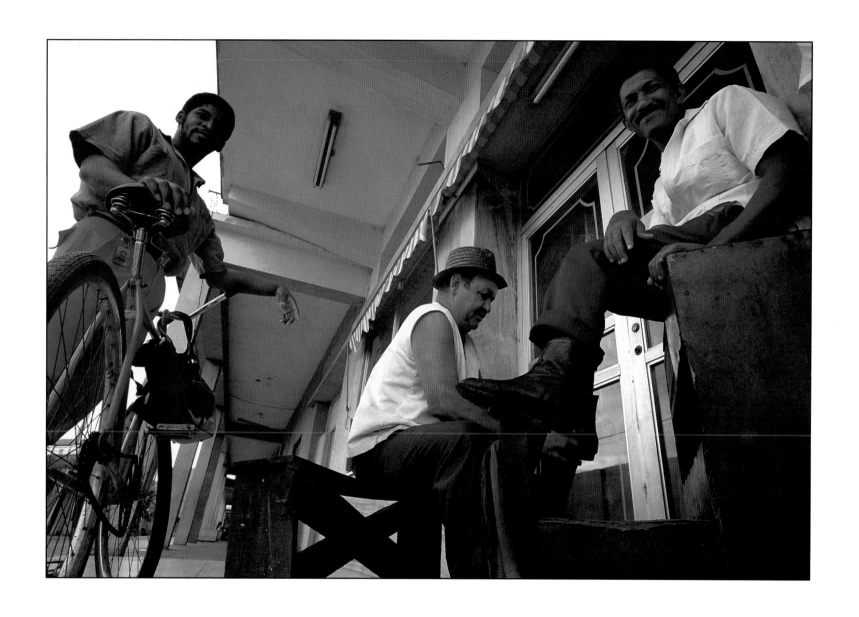

Getting a shoe shine. Nueva Gerona, Isle of Youth.

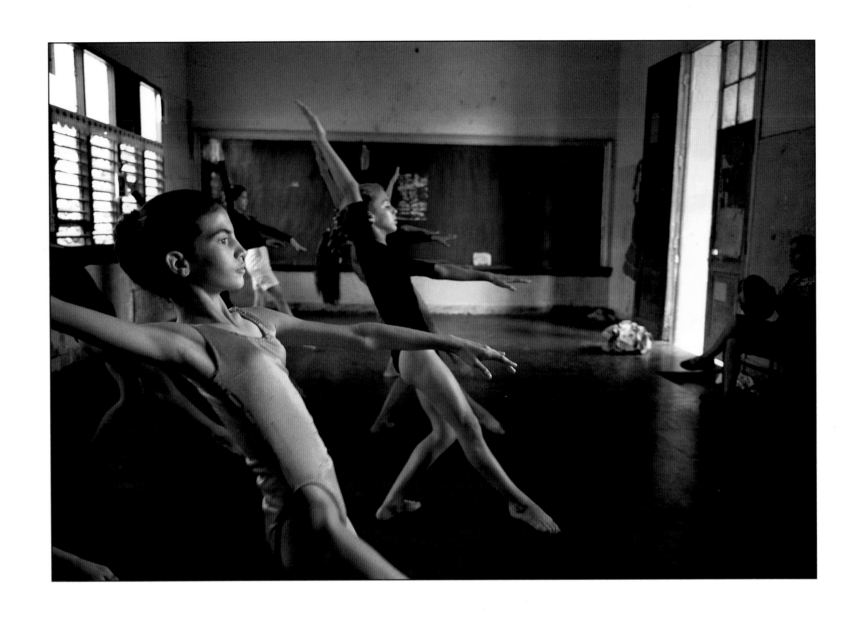

At a performing arts high school. Nueva Gerona, Isle of Youth.

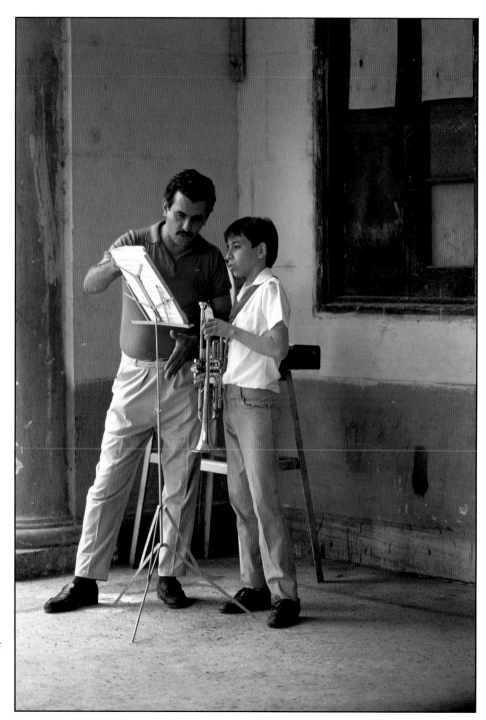

At a performing arts high school. Nueva Gerona, Isle of Youth.

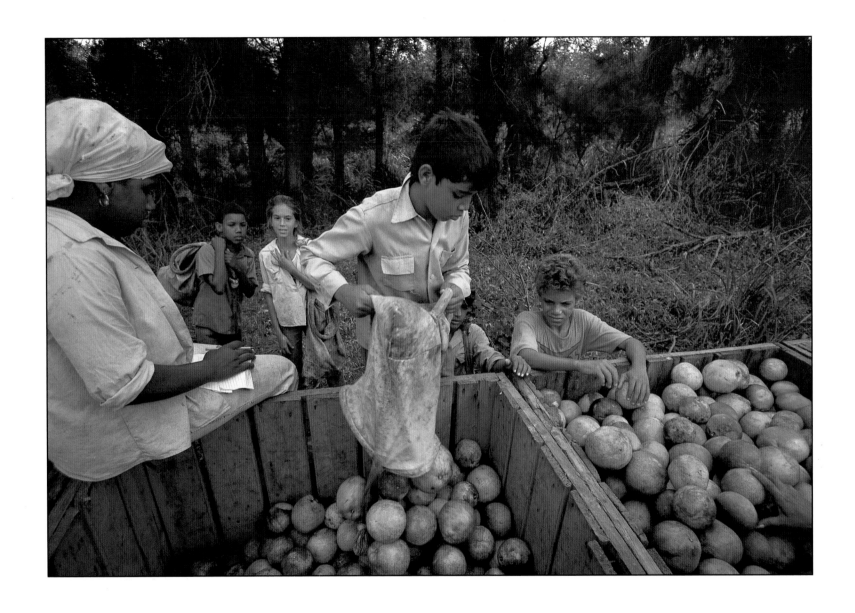

Students work the field shift at a boarding school in the countryside where they work for three hours a day and study for four hours. Isle of Youth.

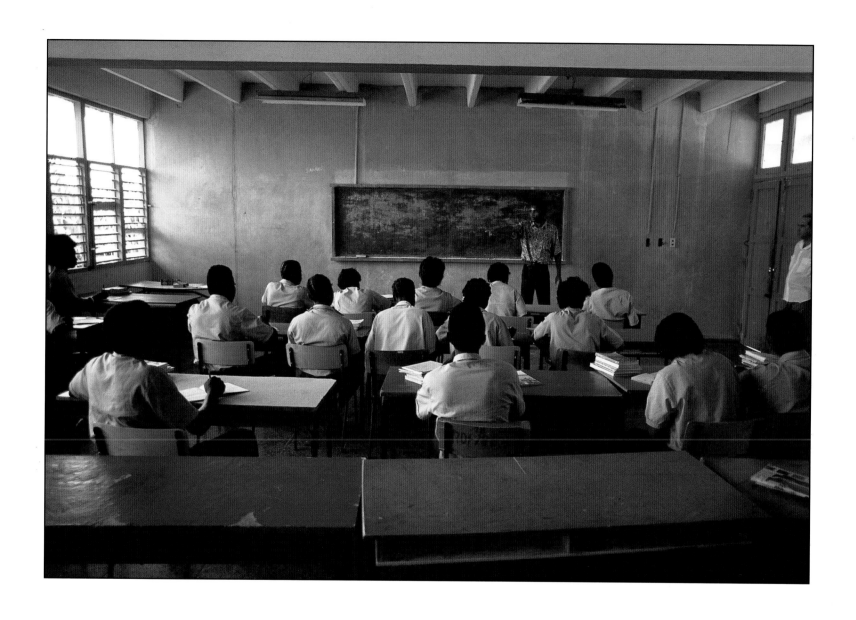

Angolan students studying English. Eighteen-thousand foreign students from around the world are currently studying on the Isle of Youth.

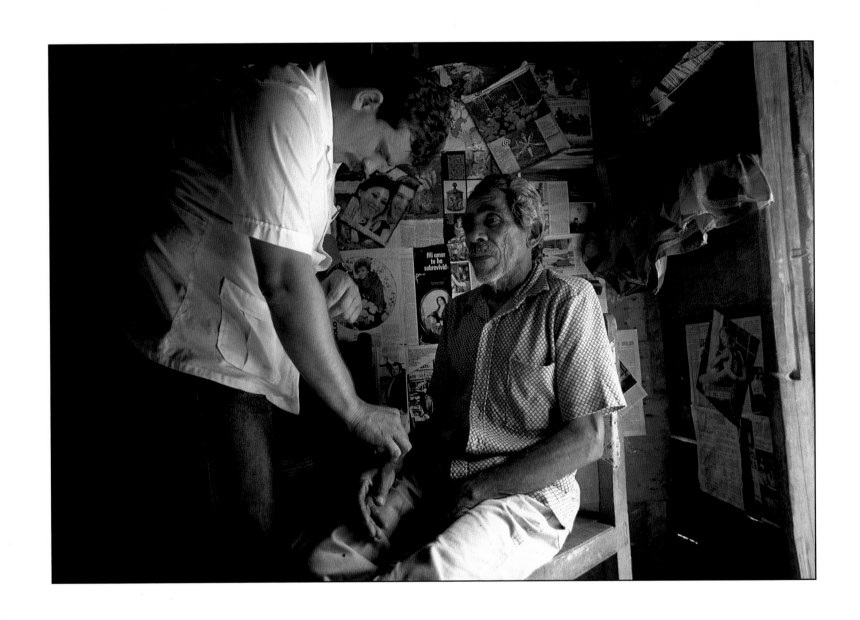

Doctor making a house call deep in the Sierra Maestra mountain range, hours away from the nearest city.

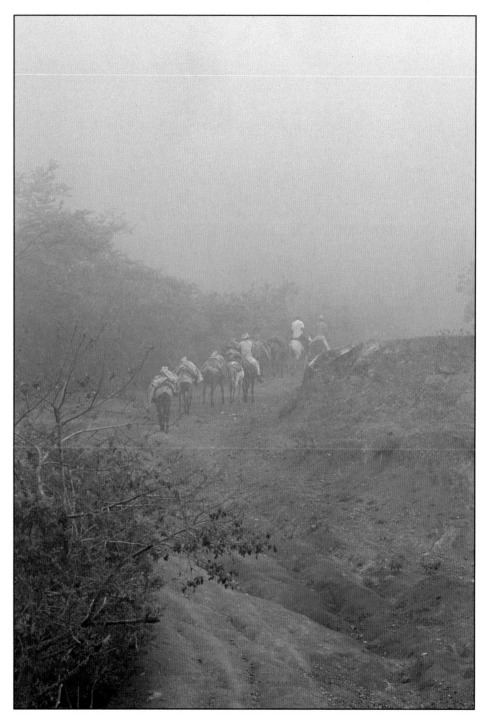

Independent coffee growers returning home after selling their beans to a state-run enterprise. Sierra Maestra.

Late afternoon. Sancti Spíritus.

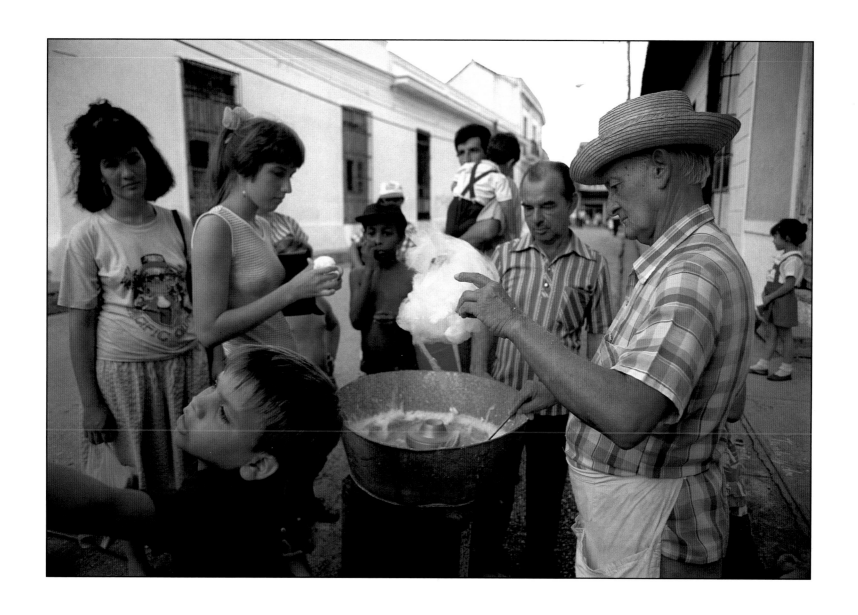

Cotton-candy seller. Sancti Spíritus.

117

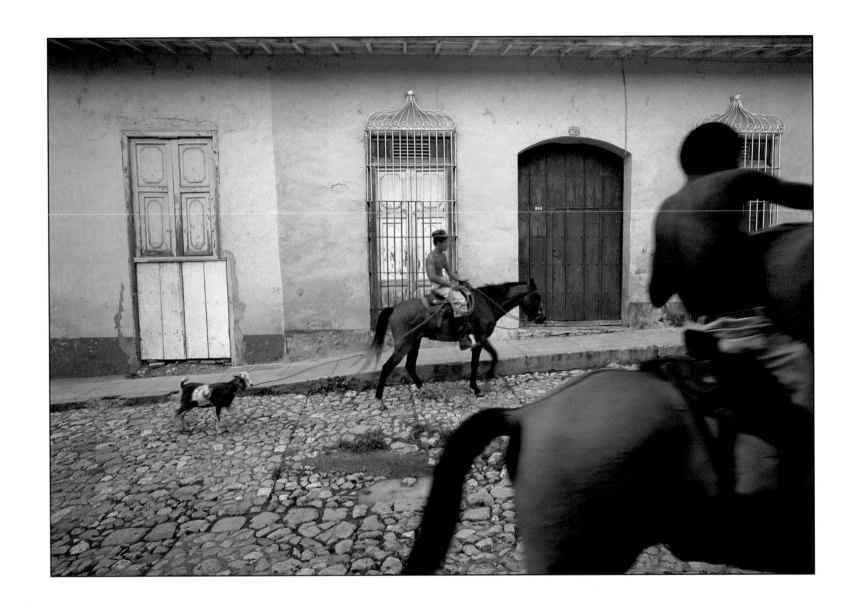

Trinidad.

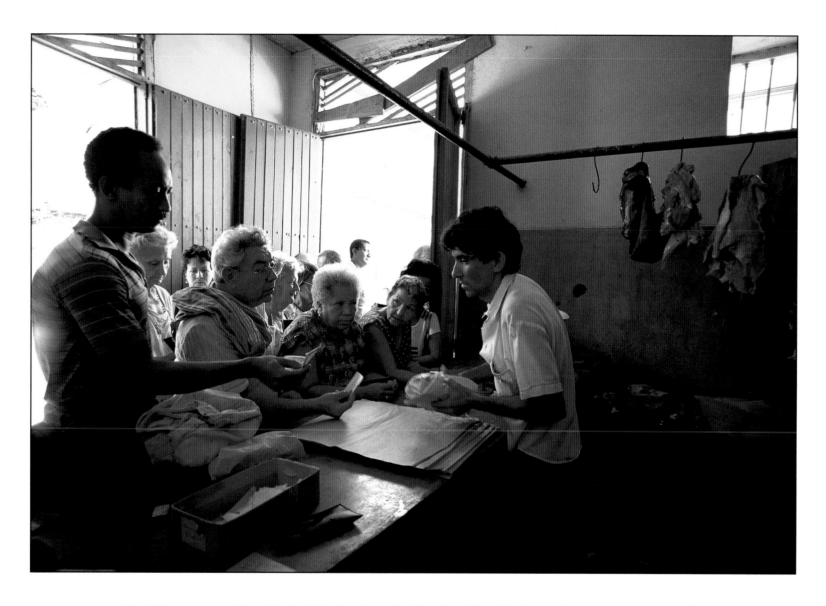

Hopeful customers with ration books in hand, at a butcher shop. The rationing system attempts to ensure that every Cuban receives an equal amount of food or products, no matter what their economic circumstances. Trinidad.

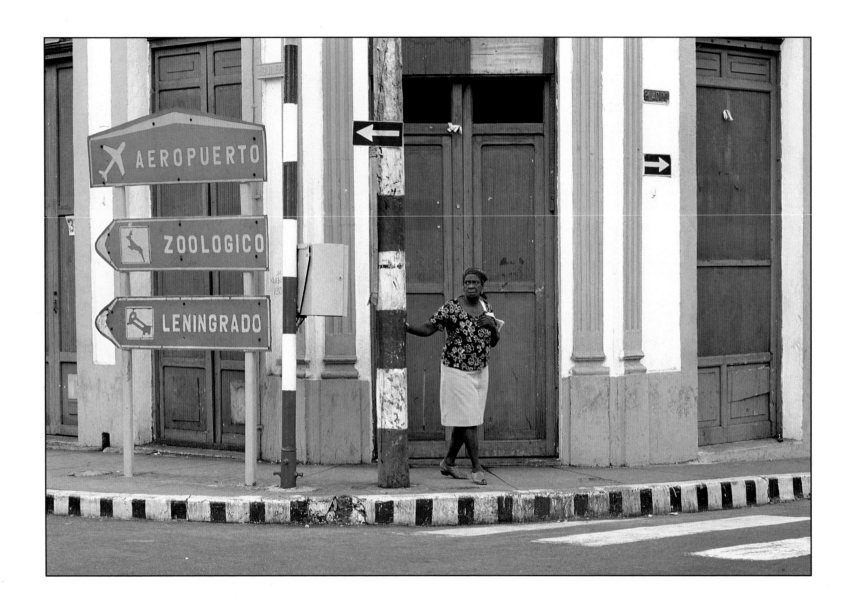

Signs point the way to the airport, the zoo, and the Hotel Leningrad. Santiago.

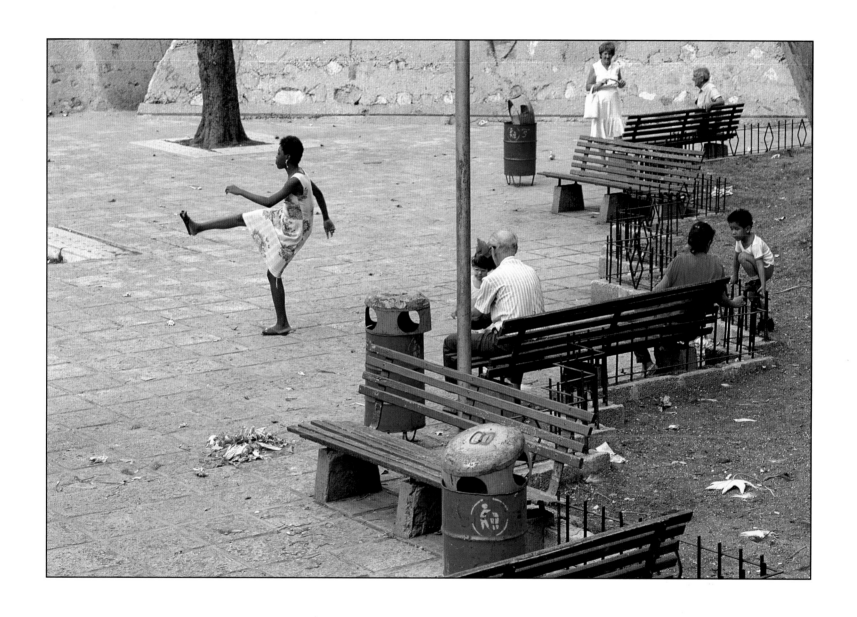

Playing soccer in a Galiano Boulevard park. Central Havana.

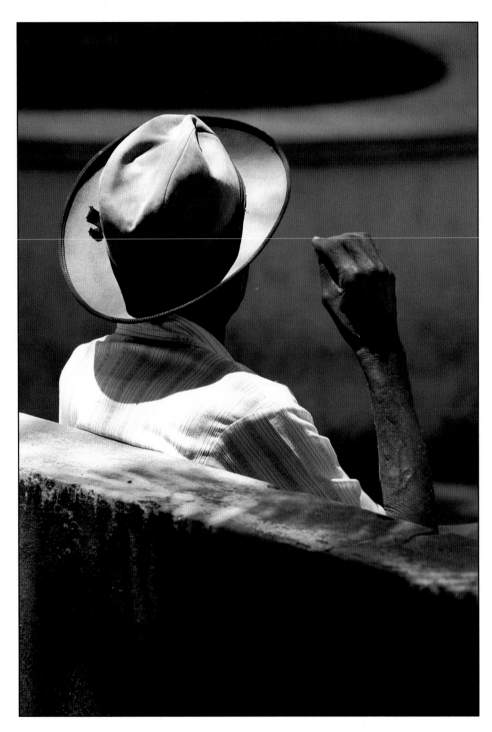

Parque Céspedes. Santiago.

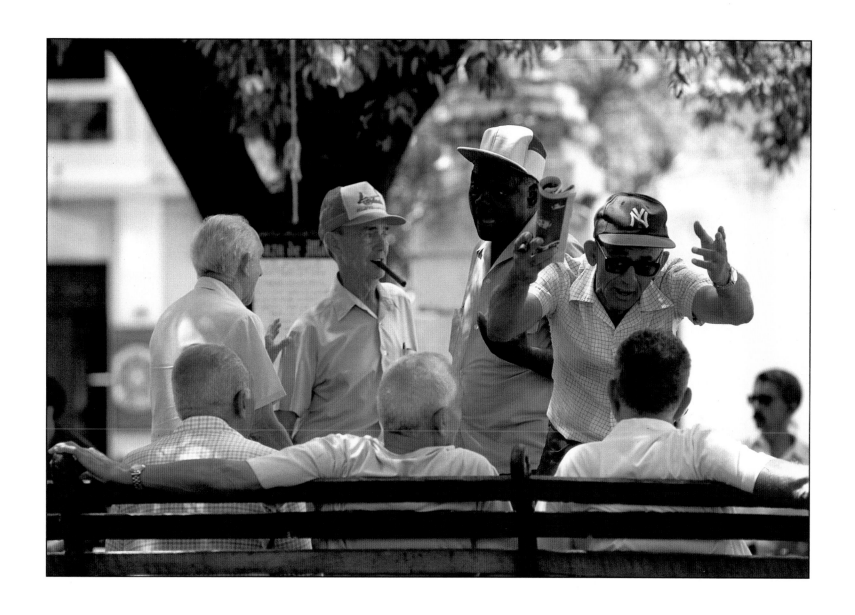

Baseball enthusiasts at Plaza Martí. Santiago.

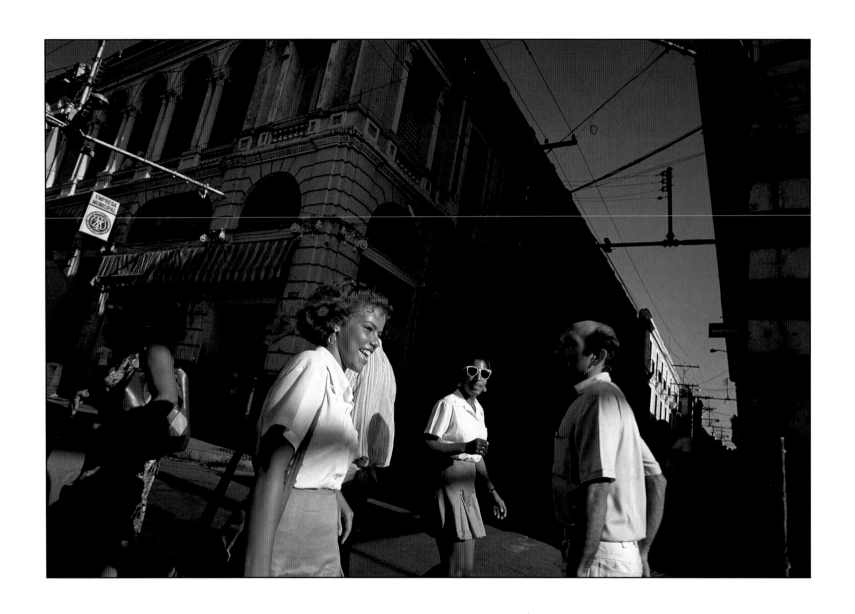

Closed to car traffic, Santiago's main street becomes a human thoroughfare.

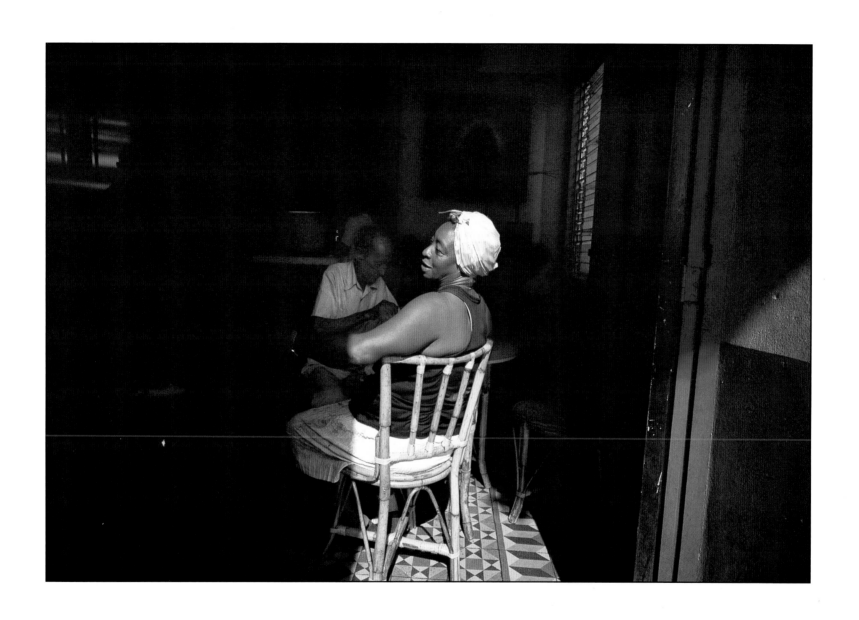

A café. Santiago.

ACKNOWLEDGMENTS

No book is ever the product of just one person and this book is no exception. First, I would like to thank my editors at W. W. Norton, Eve Picower, Jim Mairs, and Bill Rusin, for their support and encouragement. Eve, in particular, showed remarkable perseverance.

A number of people in the United States were instrumental in the editing of these images. Claudia Bernardi, a wonderful artist herself, helped in both editing and the difficult task of sequencing the images. I cannot thank her enough. Thanks also to photographers: Kim Komenich of the *San Francisco Examiner*, Ed Kashi, Ken Light, and Totoy Rocamora for their invaluable help. Kerry Tramain of *Mother Jones* magazine gave valuable input to the editing process. Lynette Molnar, photographer and director of San Francisco's Eye Gallery, lent much-appreciated encouragement. Thanks also to Miles Seligmann at *The Nation* magazine for his assistance in a thankless task. My partner, Sarah Lynch, deserves my undying gratitude for her assistance every step of the way, as well as for her patience and companionship.

Facilitating my trips to Cuba with knowledge and support were Medea Benjamin of Global Exchange, Sandra Levinson of the Center for Cuban Studies, and Bob Guild of MarAzul Tours.

In Cuba, the Cuban Friendship Institute (ICAP) helped me in many ways, from assisting with transportation and guides to arranging visits to places around the country. In particular, I would like to thank Eliselia Diaz and Alberto Fernandez. And of course, the ICAP drivers for putting up with the whims of a slightly crazy "Yanqui" photographer. Also to all of the *compañeras* of the guest house for being my family away from home (not to mention all the mangos, great coffee, and food). In Cuba, Karen Wald helped get the book off the ground, and Sonia Baez provided friendship and personal insights into Cuba during these difficult times. Various members of the Association of Cuban photographers shared their perspectives, humor, and pizza. And to Felicia Gustin in assisting in my research on Cuba and later in the process of writing the captions.

For all of my friends who I haven't mentioned by name, thanks for your support.

Last, but not least, I need to thank all the people of Cuba who let me photograph them, always with a sense of humor and an added dose of patience.

TECHNICAL NOTES

The following equipment and film was used in the creation of this book:

A Leica M6 with the following lenses: 21mm Elmarit, 28mm Elmarit, 35mm Summicron, and once or twice a 75mm Summilux.

Nikkon camera models: FA, FM2, and an 8008, with the following Nikkor lenses: 24mm f2.8, 35mm f2, 85mm f2, and the auto focus 1.8, 180mm, and once or twice a 300mm and the 500mm.

A Nikon SB 24 flash was used a few times.

Fujichrome film was used exclusively. Both 50 ASA and 100 ASA, which was usually pushed to 200.